MANGA MANIA
OCCULT AND HORROR

MANGA MANIA
OCCULT AND HORROR

HOW TO DRAW THE ELEGANT AND SEDUCTIVE CHARACTERS OF THE DARK

CHRISTOPHER HART

WATSON-GUPTILL PUBLICATIONS/NEW YORK

Executive Editor: Candace Raney
Senior Development Editor: Alisa Palazzo
Designer: Bob Fillie, Graphiti Design, Inc.
Production Director: Alyn Evans
Cover design by Kapo Ng@A-Men Project
Front cover art by Anzu
Back cover art by Regina

First published in 2007 by
Watson-Guptill Publications,
an imprint of the Crown Publishing Group,
a division of Random House, Inc., New York
www.crownpublishing.com
www.watsonguptill.com

Library of Congress Cataloging-in-Publication Data
Hart, Christopher.
 Manga mania occult and horror : how to draw
the elegant and seductive characters of the dark /
Christopher Hart.
 p. cm.
 Includes index.
 ISBN-13: 978-0-8230-1422-4 (pbk.)
 ISBN-10: 0-8230-1422-3 (pbk.)
 1. Comic books, strips, etc.—Japan—Technique. 2. Cartooning—Technique.
3. Occultism in art. 4. Horror in art. I. Title.
 NC1764.5.J3H36935 2007
 741.5'3164--dc22

 2007020131

Typeset in Veljovic, Talon, Grande Guignol, Dead Man's Folly, Arnold
Boecklin, Dave Gibbons, Divine Right

Printed in China

2 3 4 5 6 7 8 9 / 15 14 13 12 11 10 09 08

CONTRIBUTING ARTISTS:

Akemi Kobayashi
Kazuhiro Soeta
Anzu
Vanessa Duran
Cristina Francisco
Stephen Segovia
Regina

VISIT US AT
www.artstudiollc.com

CONTENTS

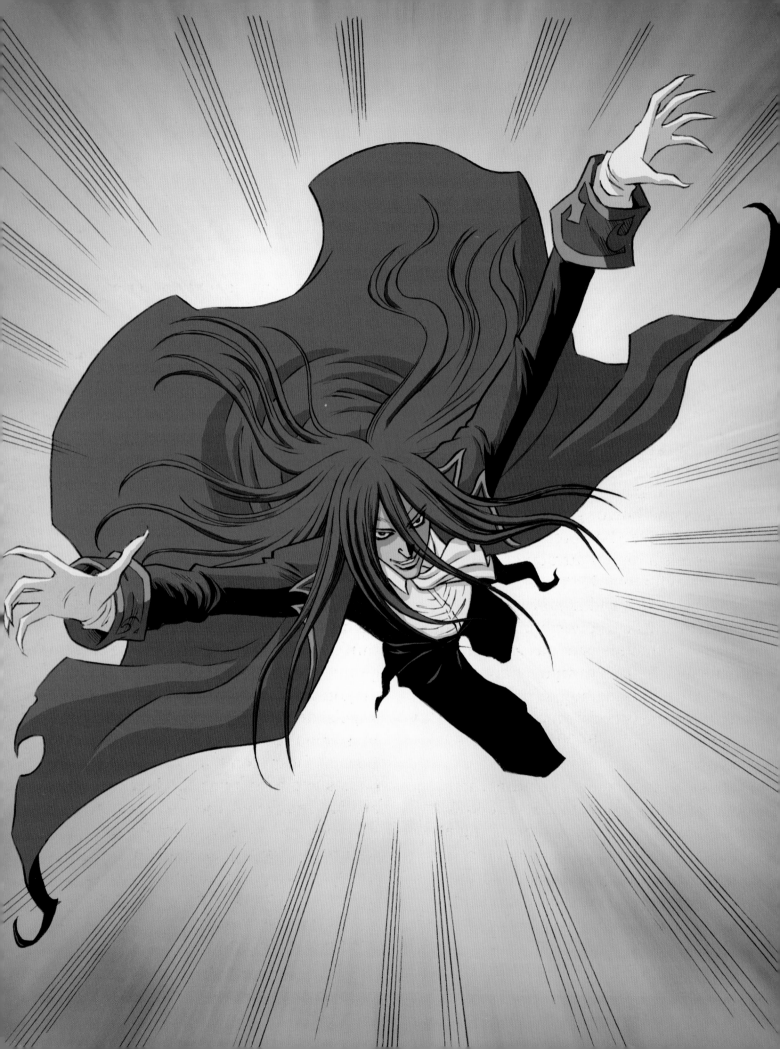

EVERY MANGA FAN IS reading *occult and horror* graphic novels. One visit to the Graphic Novels section of the bookstore will bring you to a universe of elegant occult and horror stories packed with amazing artwork from the best illustrators Japan has to offer.

The occult-and-horror style of manga is unlike any other. In American comics, the horror genre features ugly and repulsive characters, but the manga version is a highly attractive style, where evil never looked so good. In manga, occult and horror are often combined into one form in which the occult characters, such as glamorous male and female vampires, are cast in the same story as horror characters, such as beasts and demons. It's a darkly graceful world, a breathless roller-coaster ride.

It's also in a category entirely its own. Artistically speaking, the look is strikingly different from anything else. The proportions of the characters are long, like models, yet at the same time, the figures exude a powerful presence. The faces are somewhat androgynous, and it's an ambiguity that is also expressed in the very nature of the characters, who hover between two worlds—one of light and one of darkness.

The cast of characters, the costumes, the supernatural powers, and the haunting environments are unique to this genre. All of these elements conspire to makes this one of the most compelling, complex, and alluring styles in all of manga—and one of my personal favorites.

This book strives to show you, in-depth and step-by-step, how to draw the faces of all of the popular occult and horror character types, as well as their detailed expressions. Lest you think vampires are all there is to this genre, included are tarot card readers, dragon worshippers, wizards, dark angels, demon children, and the other mysterious denizens of the night. Beyond faces, you'll learn about bodies and action poses. Then there are the details: vampire wings of all varieties and sizes, vampire-to-bat transformations, human-to-beast transformations, the secrets of costume design, how to use light and shadow to create intense moments, and how to use the colors of evil. This is the cutting edge of manga.

The world of occult and horror is filled with strikingly cool characters. The dangerous and seductive quality of the occult genre makes it a slightly more mature style. It is the ultimate combustible combination of evil and romance. The magnetic characters require special proportions and special flourishes to bring out their wickedness, so the art techniques included here are specially designed to create these alluring creatures of the darkness.

THE ELEGANCE OF OCCULT

General Genre Comparison

It's one thing to *describe* the differences between occult/horror and the other genres of manga. It's another to actually *see* them compared, side by side. For the comparisons on the next few pages, the occult-and-horror style is juxtaposed with the shoujo (pronounced show-joe) style, since shoujo (famous for its young characters with big eyes) is the most popular manga style in the West. As you can see, there are significant stylistic differences.

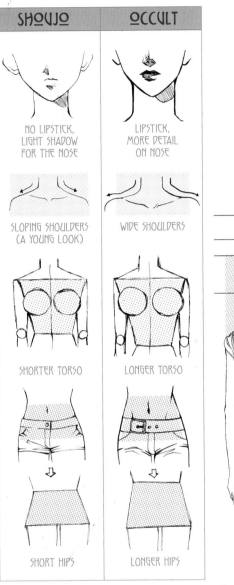

SHOUJO	OCCULT
NO LIPSTICK, LIGHT SHADOW FOR THE NOSE	LIPSTICK, MORE DETAIL ON NOSE
SLOPING SHOULDERS (A YOUNG LOOK)	WIDE SHOULDERS
SHORTER TORSO	LONGER TORSO
SHORT HIPS	LONGER HIPS

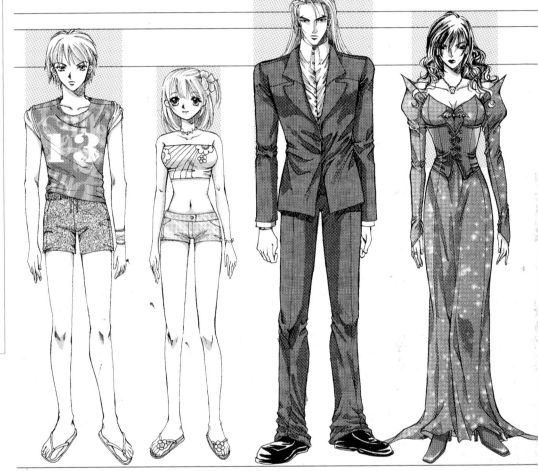

SHOUJO OCCULT AND HORROR

Elegant Occult & Horror Characters Are . . .

- more mature than shoujo characters.
- alluring.
- tall.

- fully grown. (They're often in their twenties.)
- broad in the shoulders. (This adds impressive stature to otherwise lanky builds.)

- sharp dressers, with a European flair. (They don't shop at discount stores—plus, they dress for night.)
- well-coiffed. (These are expensive salon haircuts.)

Shoujo Men vs. Occult Men

Can you sense the power of the occult character as his piercing eyes look right through to your soul? The typical manga (i.e., shoujo) man—a boy really—would be no match for the occult guy, who just oozes physical and mental power. (Again, for the purpose of comparison, I'm using shoujo manga, so I may refer to the shoujo style as "typical" manga.)

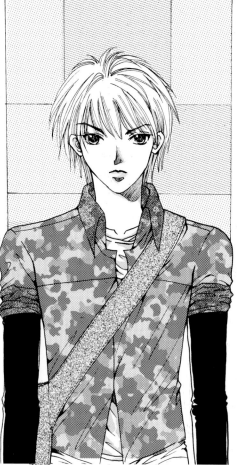

SHOUJO

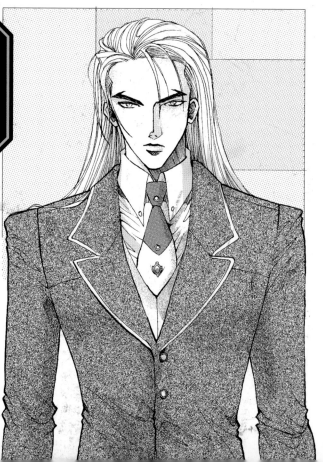

Dress like a Man

It's important that your occult characters *not* dress like boys. They should dress like *men*, in *dapper* clothing.

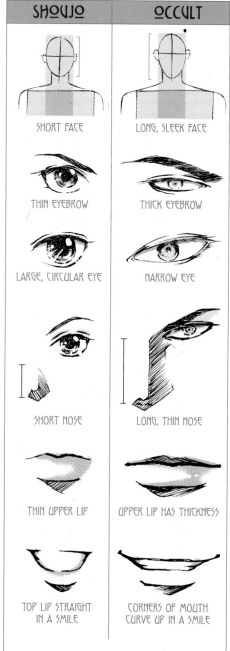

SHOUJO	OCCULT
SHORT FACE	LONG, SLEEK FACE
THIN EYEBROW	THICK EYEBROW
LARGE, CIRCULAR EYE	NARROW EYE
SHORT NOSE	LONG, THIN NOSE
THIN UPPER LIP	UPPER LIP HAS THICKNESS
TOP LIP STRAIGHT IN A SMILE	CORNERS OF MOUTH CURVE UP IN A SMILE

Shoujo Women vs. Occult Women

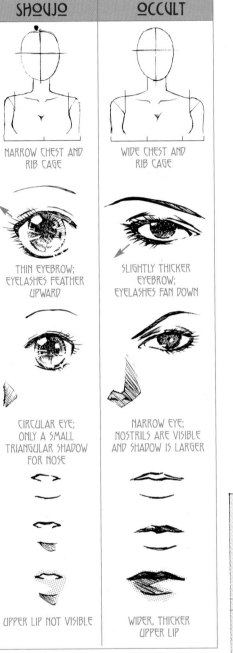

SHOUJO	OCCULT
NARROW CHEST AND RIB CAGE	WIDE CHEST AND RIB CAGE
THIN EYEBROW; EYELASHES FEATHER UPWARD	SLIGHTLY THICKER EYEBROW; EYELASHES FAN DOWN
CIRCULAR EYE; ONLY A SMALL TRIANGULAR SHADOW FOR NOSE	NARROW EYE; NOSTRILS ARE VISIBLE AND SHADOW IS LARGER
UPPER LIP NOT VISIBLE	WIDER, THICKER UPPER LIP

As with the men, many small adjustments in the features of the occult character's face add up to a huge difference in final drawing. In addition to her slightly more devious look, full athletic shoulders create a sexy and strong appearance. (Dangerous females should look stronger than more innocent characters.) Notice, too, that female occult costumes usually look heavy. That's because they make use of gothic details, including ties, knots, buttons, and so on. Oh, and get a look at that tattoo on her shoulder.

SHOUJO

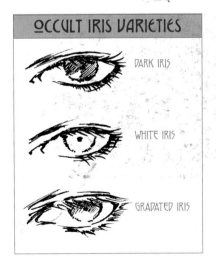

OCCULT IRIS VARIETIES	
	DARK IRIS
	WHITE IRIS
	GRADATED IRIS

OCCULT AND HORROR

The Head

Let's start with a medium shot. Why the medium shot, and what is it? The *medium shot* shows a little more of the character's torso than a simple head shot (which, as the name implies, just shows the head alone). The medium shot reveals a bit of the neck and shoulders, and this suits the occult genre because the mysterious mood of the characters is integrated into the costume, the long neck, and the wide shoulders. Removing those elements detracts from the image. So, this kind of shot establishes the style and identity of the character.

MALE FRONT VIEW

We'll start with a male character in the classic front view, eventually completing the full "turnaround" over the next few pages. What's a *turnaround*? That's the practice of drawing a single character in a variety of angles that progress around the figure. By doing so, you gain the ability to do the thing with which many artists have difficulty: making your character look the same from all directions. This is essential! Be honest; haven't you sometimes chosen to draw a character at a certain angle—for example, in profile—because you have trouble drawing it from a different angle? Drawing turnarounds is the way to bust through that sticking point.

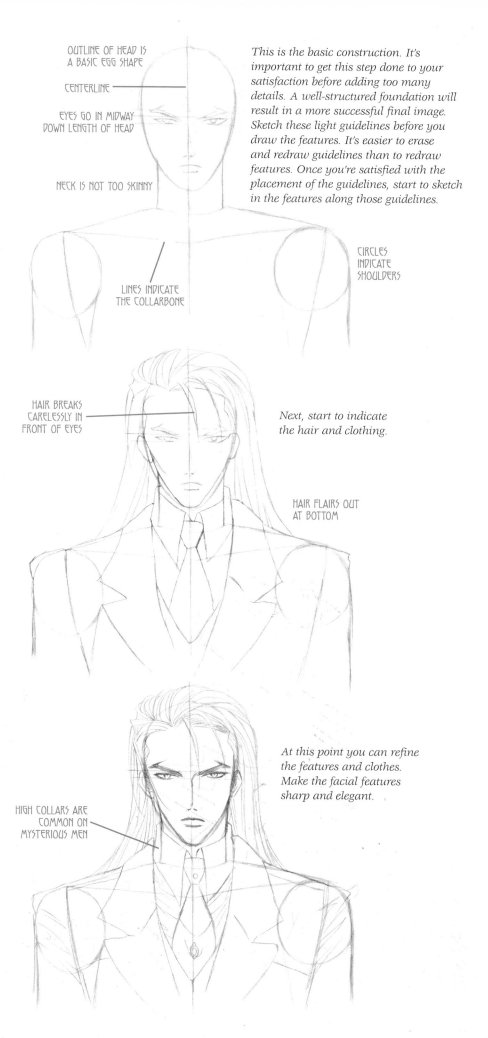

OUTLINE OF HEAD IS A BASIC EGG SHAPE

CENTERLINE

EYES GO IN MIDWAY DOWN LENGTH OF HEAD

NECK IS NOT TOO SKINNY

LINES INDICATE THE COLLARBONE

CIRCLES INDICATE SHOULDERS

This is the basic construction. It's important to get this step done to your satisfaction before adding too many details. A well-structured foundation will result in a more successful final image. Sketch these light guidelines before you draw the features. It's easier to erase and redraw guidelines than to redraw features. Once you're satisfied with the placement of the guidelines, start to sketch in the features along those guidelines.

HAIR BREAKS CARELESSLY IN FRONT OF EYES

HAIR FLAIRS OUT AT BOTTOM

Next, start to indicate the hair and clothing.

HIGH COLLARS ARE COMMON ON MYSTERIOUS MEN

At this point you can refine the features and clothes. Make the facial features sharp and elegant.

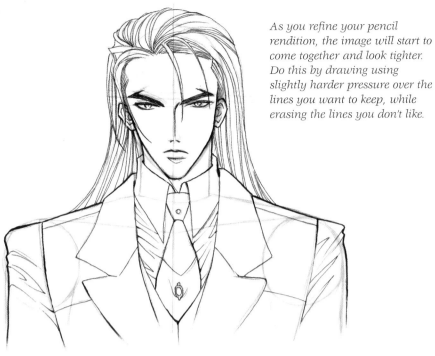

As you refine your pencil rendition, the image will start to come together and look tighter. Do this by drawing using slightly harder pressure over the lines you want to keep, while erasing the lines you don't like.

When the pencil version is finished, ink can be applied over the pencil lines. Once the ink is dry, you can erase any still-visible pencil guidelines. (Erase gently using a good, art-quality eraser, which you can find in any art supply store.) Do not erase until the ink is dry or your image will smudge.

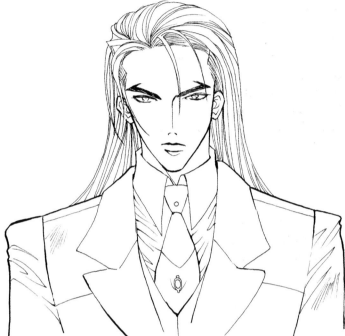

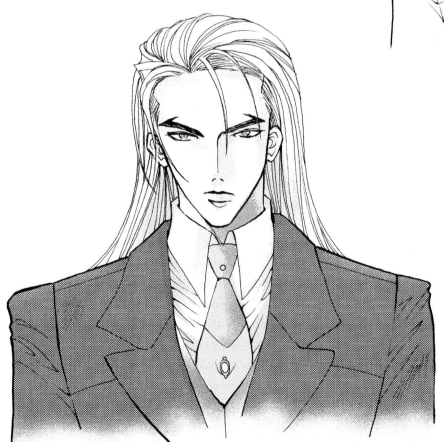

Hint: Sketching

Draw lightly at first. You're putting down construction lines, basic shapes, and guidelines. You'll be erasing many of these lines later on in the process. Therefore, *don't press down too hard on your pencil.* In addition, try not to make very short, choppy, feathery strokes. Comfortable, loose pencil strokes are the best. As in baseball, the key is to "swing away." Loosen up on the pencil. Tightening up constricts your creativity. It makes you worry too much about "getting it right." This isn't the part where you try to get it right. This is the part where you experiment and see what happens. Can't do that if you're squeezing the graphite so hard that nothing spontaneous can flow from your hand.

FEMALE FRONT VIEW

The gaze of a beautiful seductress should be unafraid, almost unnerving, as if you would lose your will if you looked too long into those eyes. It's a beauty you can't trust—a savage beauty—because it masks a hideous violence and hunger. And yet, a man could so easily lose his way, staring into her face.

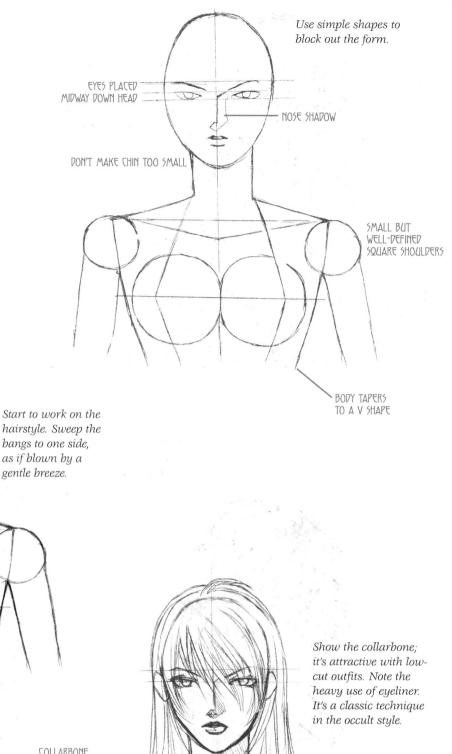

Use simple shapes to block out the form.

EYES PLACED MIDWAY DOWN HEAD

NOSE SHADOW

DON'T MAKE CHIN TOO SMALL

SMALL BUT WELL-DEFINED SQUARE SHOULDERS

BODY TAPERS TO A V SHAPE

Start to work on the hairstyle. Sweep the bangs to one side, as if blown by a gentle breeze.

Show the collarbone; it's attractive with low-cut outfits. Note the heavy use of eyeliner. It's a classic technique in the occult style.

COLLARBONE

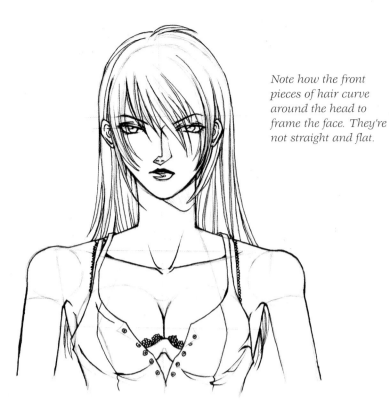

Note how the front pieces of hair curve around the head to frame the face. They're not straight and flat.

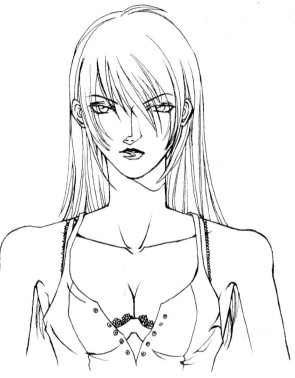

The shine in the bottom lip is indicated before the drawing is inked.

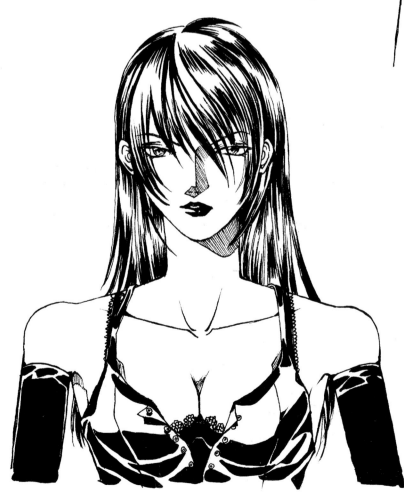

Hint: Inking

When you add shading to the interior areas of the figure (within the outlines), leave any raised parts of fabric folds white. Also, limit cross-hatching, using it only for small shadows cast on the face and neck.

MALE PROFILE

Another reason it's important to show a suggestion of the body in the turnarounds is that it gives a glimpse of the posture, which supports the facial expression. In American comics, bad guys generally have craven postures; they're evil, so they're cowards at heart. Not so in the manga occult-and-horror genre. These characters may be introverted, troubled souls, but they're heroes in a strange, dark way. They just happen to be cursed. They still have a charismatic self-assurance that the audience admires. So, they hold their head high, chest out, with a confident look in their eye and an eyebrow that crushes down in a determined manner.

PROFILE FALLS ALONG AN ARCHING GUIDELINE

Notice the square "guide box" lightly sketched around the chest area. It basically aligns with the front of the stomach, but extends farther behind the back of the character. This helps artists remember to indicate that there is mass in the back behind the shoulder area. Don't draw a flat back that ends at the arms; this makes the back look like a flat board.

SHOW FAR COLLAR

Start to sketch in the hair and clothes. Note that, in the profile, you should still be able to see elements on the far side of the head.

KEEP TIP OF NOSE SHARP

DRAW INDIVIDUAL PIECES OF HAIR FOR ELEGANT LOOK

Refine the facial features, hair, and clothes.

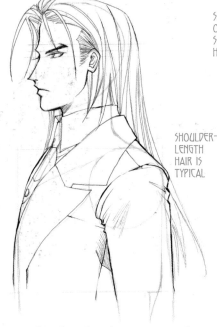

SHOULDER-LENGTH HAIR IS TYPICAL

Don't skip these foundation steps and go straight to drawing the clothed figure. Take a moment to block out the pose first.

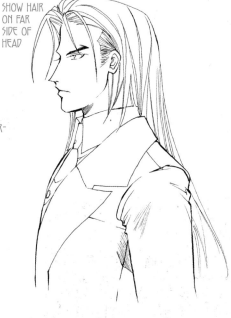

SHOW HAIR ON FAR SIDE OF HEAD

This character looks so powerful because the body has been carefully sketched out first—underneath the layers of garments.

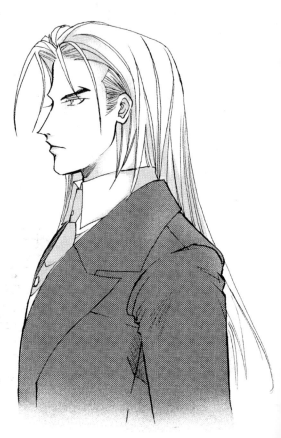

FEMALE PROFILE

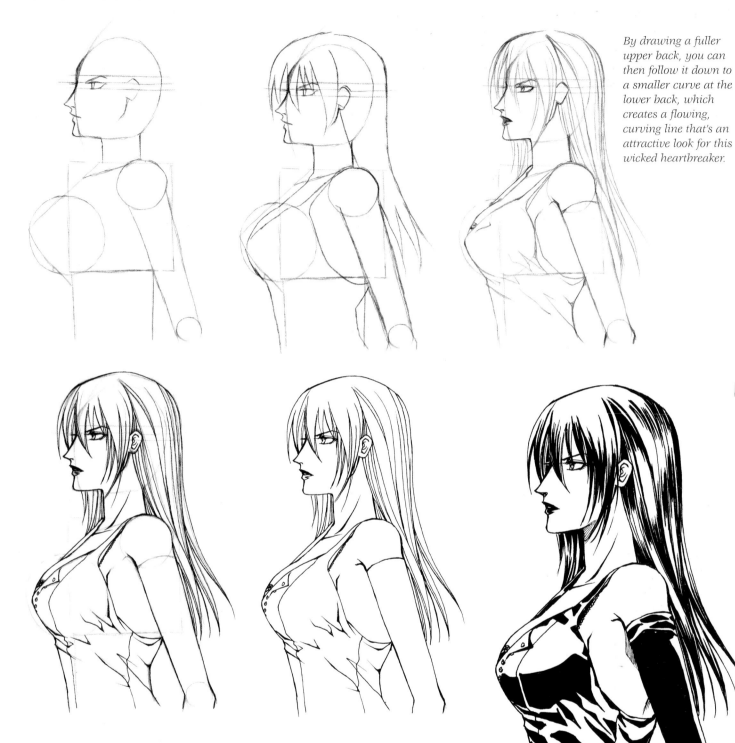

By drawing a fuller upper back, you can then follow it down to a smaller curve at the lower back, which creates a flowing, curving line that's an attractive look for this wicked heartbreaker.

Gloves: Not Just for Your Grandmother

Here's a rule you can put in your repertoire: The higher the gloves, the more evil the character. When gloves reach above the elbow, they denote a character with sinister intentions. There are exceptions, such as magical girls (who fight for good) and a few sci-fi costumes. But by and large, when gloves reach the shoulder, your character is bad to the bone.

MALE 3/4 VIEW

You probably see characters portrayed in the 3/4 view more often than in any other angle. Why is that? Because it's the way things have to be. Think about it. For characters to be in a front view, they have to be facing exactly forward. If the face moves to the left or to the right, even slightly, it becomes a 3/4 view. If characters are in profile and the face moves toward the reader, even slightly, it becomes a 3/4 view. Therefore, unless front and side views are exact, they instantly become 3/4 views. And, 3/4 views don't have to be perfect; there are many angles that fall in the 3/4 range. That's why you see 3/4 views all the time.

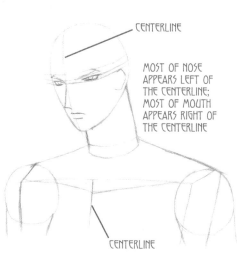

CENTERLINE

MOST OF NOSE APPEARS LEFT OF THE CENTERLINE; MOST OF MOUTH APPEARS RIGHT OF THE CENTERLINE

CENTERLINE

The success or failure of the 3/4 pose depends on the guideline placement (both of the centerline and the eye lines). The bridge of the nose falls where the guidelines intersect. You can judge where to place the eyes relative to how far they will be from the centerline: The near eye will be farther from the centerline than the far eye, due to perspective (see next step). The center of the upper lip is bisected by the centerline, but note that in the 3/4 view the centerline is not in the center anymore—it falls 3/4 of the way around the form.

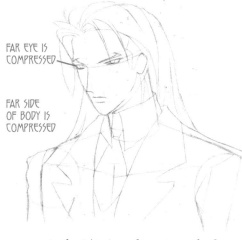

FAR EYE IS COMPRESSED

FAR SIDE OF BODY IS COMPRESSED

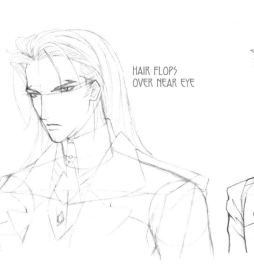

HAIR FLOPS OVER NEAR EYE

In the 3/4 view, elements on the far side of the body appear compressed, following the principles of perspective, which state that as things recede into the distance they appear smaller.

As you refine the features and clothes, notice that the jaw is very slender in this view.

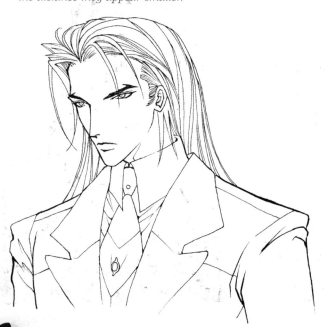

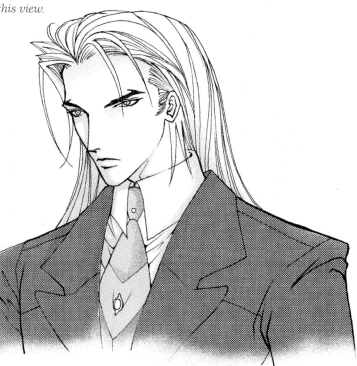

Utilize a slight downward head tilt for sinister, less innocent characters. A slight upward tilt is for hopeful characters.

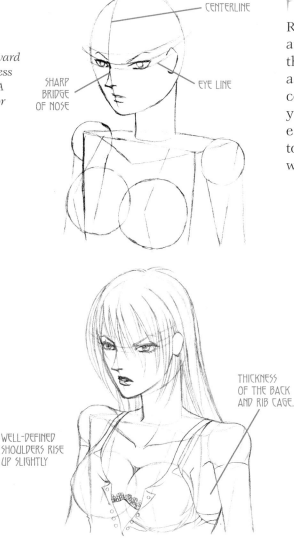

CENTERLINE

EYE LINE

SHARP BRIDGE OF NOSE

FEMALE 3/4 VIEW

Resist the temptation to add hair and other stuff too soon. Finish the basic construction first, just as you see it here in the first construction step. Trust me, you'll be amazed how much easier—and more effective—it is to go in order. And your drawing will look a lot better for it.

WELL-DEFINED SHOULDERS RISE UP SLIGHTLY

THICKNESS OF THE BACK AND RIB CAGE.

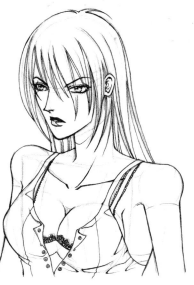

For women in 3/4 view, the side of the face must be somewhat softer (rounder) and not as sharp and angular as it is for men.

The 3/4 view reveals the thickness of the back and rib cage.

Darken areas that are the focus of the character: eyes and lips.

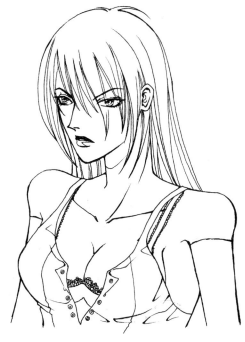

Light sources come from many angles. Those that come from below create spooky effects. Those from the side produce dramatic effects. But unless they have some particular purpose in mind, artists generally indicate that the light source comes from overhead. (Overhead light is the most common form of lighting; sunlight, interior lighting, nighttime streetlights, and moonlight are all overhead light.) The source of the light is indicated here by the irregular white (or lighter-colored) areas on top of the head and on the upper parts of the form (the blouse, for example). This will read as a shine from the light above.

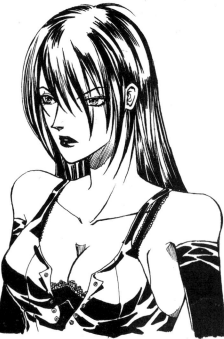

Elegant Eyes

You can learn to draw the basic shape of the eye in any art-instruction book. However, that's not going to help you when you want to draw manga. The eyes here are different even from typical manga, because the eyes of occult characters are completely unlike the run-of-the-mill manga eyes you see on most Japanese comic characters. And then there are different styles of eyes for different *types* of occult characters. But you're not leaving a Chris Hart book without the inside scoop.

Let's start with the shape. Two words: not tall. That's right, occult-style eyes are not tall like so many other popular styles of manga eyes. Instead, they're sleek, narrow, and very horizontal—almost almond-shaped. Keep that foremost in mind. It's your starting point!

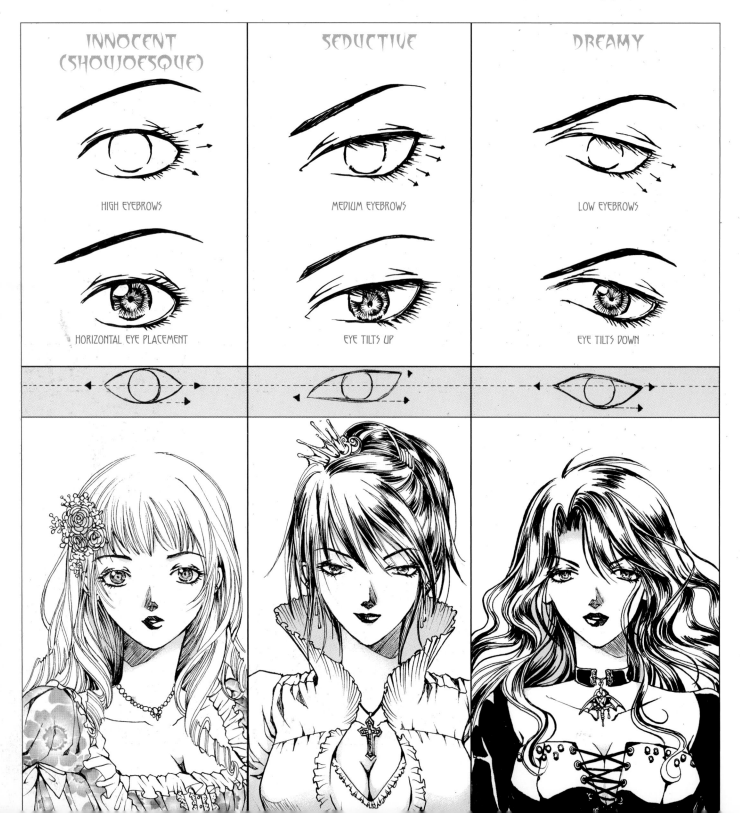

INNOCENT (SHOUJOESQUE)

HIGH EYEBROWS

HORIZONTAL EYE PLACEMENT

SEDUCTIVE

MEDIUM EYEBROWS

EYE TILTS UP

DREAMY

LOW EYEBROWS

EYE TILTS DOWN

The next thing to notice is that the iris is *textured*. It's not a solid black dot with a couple of shines in it. It's streaked, the same way a real iris is. This gives it an enchanting, mesmerizing look. The streak pattern in the iris should pinwheel out from the pupil at the center.

Moving on, prodigious eyelashes are essential— and they've got to be drawn as if the character has an arsenal of mascara. Upper and lower eyelashes are both articulated—most heavily at the outer edges. In this genre, the lower eyelashes are almost as heavy as the upper ones.

Finally, the eyebrows should have a high arch but angle sharply *down* as they travel toward the bridge of the nose. This imparts a touch of wickedness.

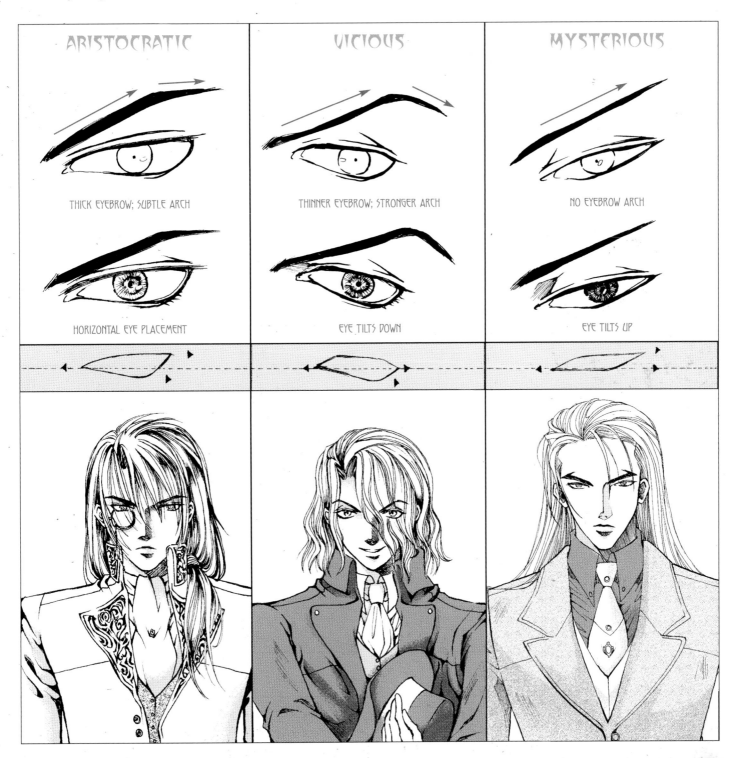

ARISTOCRATIC

THICK EYEBROW; SUBTLE ARCH

HORIZONTAL EYE PLACEMENT

VICIOUS

THINNER EYEBROW; STRONGER ARCH

EYE TILTS DOWN

MYSTERIOUS

NO EYEBROW ARCH

EYE TILTS UP

Ordinary Hair vs. Dramatic Hair

One of the things that makes occult characters occult characters is that they have mysterious forces working on them that ordinary people do not see or experience. What are these forces? Ghostly, unseen beings from the afterlife, spirits, demon possessions, and other weird stuff. A curtain rippling but the window is closed. A séance when a candle is suddenly blown out. These things occur in the realm of the supernatural. A strange and unholy wind is one of the more common signs of the presence of the supernatural.

Adding long, dramatic hair that blows curiously in the breeze, even if there is no breeze—and even when the character is indoors—adds to the feeling that we are in the presence of a being possessed by the dark forces of nature. Take a look at these two comparisons.

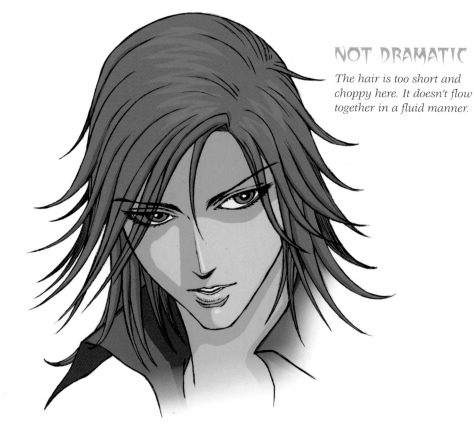

NOT DRAMATIC

The hair is too short and choppy here. It doesn't flow together in a fluid manner.

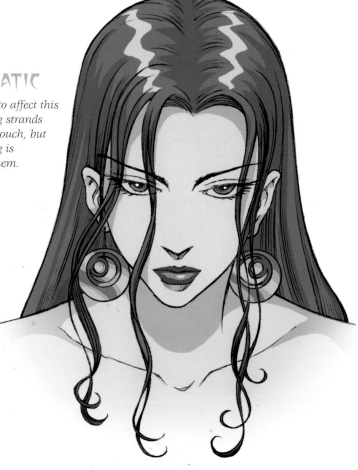

NOT DRAMATIC

There's no breeze to affect this hairstyle. The long strands are a good occult touch, but nothing interesting is happening with them.

DRAMATIC

The extra long hair wafting in the wind, along with the darkened quality of the eyes (which, by contrast, heightens the sallow pallor of the face) brings an added sense of the supernatural to the character. In addition, androgyny is a popular element in many styles of manga stories that have romantic leading men. With male occult characters, this androgyny is even more pronounced due to the darker eyes. This leads to a more feminized look, which manga readers understand as simply a sign of extreme wickedness.

DRAMATIC

The hair is fantasy-oriented, blowing randomly not so much from a breeze but as if levitated by some dark spirit. And it is topped off with a bejeweled headband. (Note the denser eye makeup, fuller and darker lipstick, and thicker eyebrows, which, not coincidentally, are drawn at a sharper angle.)

Expressions

There are many types of characters in the occult and horror genre, and not all of them are evil. For example, there are the vampire hunters, whose job it is to kill vampires and other beings of darkness. Then there are the innocent victims, the women who are seduced by the elegant and charismatic evil ones. They are also part of this fascinating genre, and all of them have their own classic expressions. As a manga artist drawing in this popular style, you'll want to make use of these figures so that your cast of characters, and your story, doesn't remain one-note.

DEMON BOY:
SKEPTICAL

PART IN UNUSUAL SPOT
FOR A UNIQUE LOOK

DEMON BOY:
THOUGHTFUL

In the world of light and magic, there are faeries. But in the world of only night, there are demon boys. They can seem sad, even gentle, and you might want to have sympathy for them. Don't! They are wild at heart—and cannot be trusted.

DEMON BOY:
VICIOUS

"HUMANS ARE
SUCH FOOLS!"

DEMON BOY:
INTRIGUED

VAMPIRE FIGHTER: CHEERFUL

Vampire fighters are usually young because we equate youth with the qualities of innocence and earnestness, which vampire fighters have in spades. So, they are one of the few character types in this genre to have a shoujo look.

VAMPIRE FIGHTER: CONFIDENT

ELEGANT MYSTERY MAN: CURIOUS

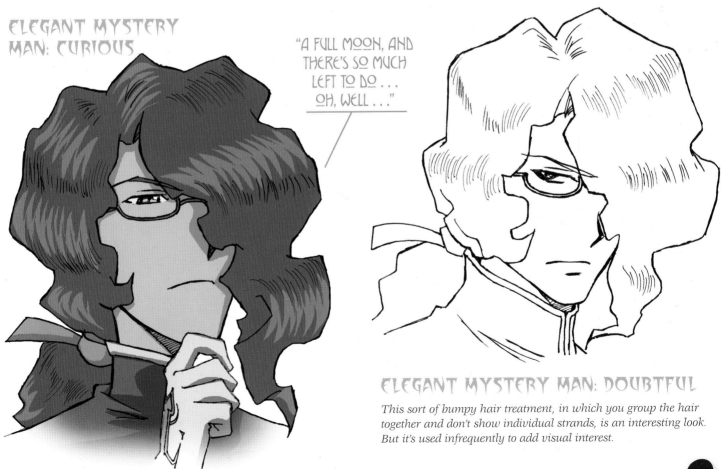

"A FULL MOON, AND THERE'S SO MUCH LEFT TO DO . . . OH, WELL . . ."

ELEGANT MYSTERY MAN: DOUBTFUL

This sort of bumpy hair treatment, in which you group the hair together and don't show individual strands, is an interesting look. But it's used infrequently to add visual interest.

THE LOVE INTEREST: LOST IN THOUGHT

Oh, boy. She has fallen for a vampire, and fallen hard. We've all known a "good girl" who has fallen for a "bad boy." This is more of the same—only worse!

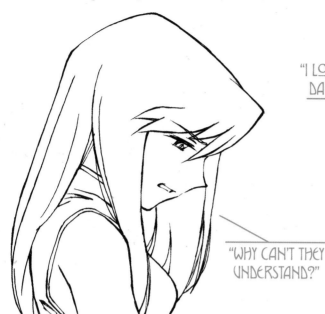

"WHY CAN'T THEY UNDERSTAND?"

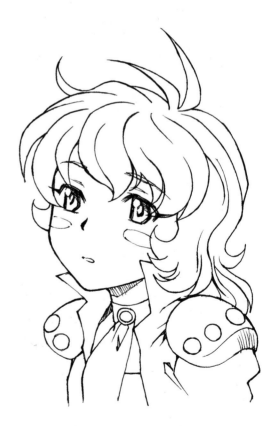

"I LOVE HIM, DAMMIT!"

THE LOVE INTEREST: CRYING ANGRY TEARS

VAMPIRE HUNTER: REFLECTIVE

Since this character goes against type—she's pretty and sweet looking—give her shoulder pads with rivets in them, expressly made for fighting, to show that she belongs in this story and genre.

VAMPIRE HUNTER: HOPEFUL

LEADER OF THE RESISTANCE: DECIDING

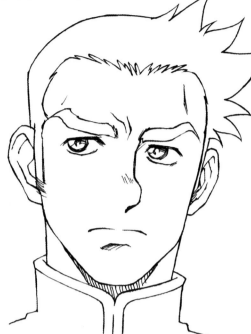

LEADER OF THE RESISTANCE: DETERMINED

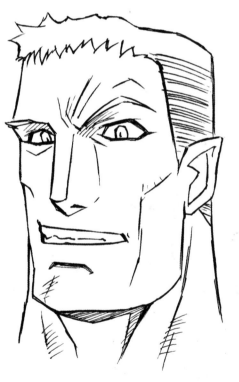

Fighting the underworld is no easy task. Sometimes, you've got to find someone who knows the ropes—in other words, a slightly older guy with a thick neck. (Guys with thick necks are always good at fighting—at least in manga. In real life, who knows? But they have a heck of a time finding shirts with collars that fit.)

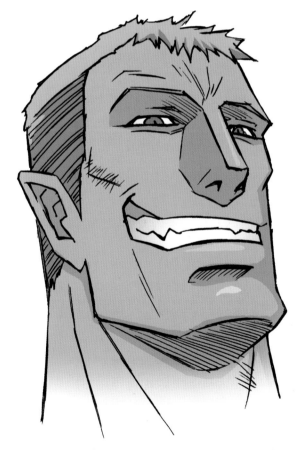

BLOCKHEAD: SINISTER GRIN

BLOCKHEAD: PERPLEXED

This guy can be a hero or a villain. Note the semipointed ears and the narrow, beady eyes. The jagged teeth and hair are indications of a guy you wouldn't want to date your sister.

A Show of Hands

Hands have character, just like faces. Usually, it's a subtle thing. Not so in the occult-and-horror genre—in which a full moon can change a beautiful woman into a feral beast. Here, hands can turn into claws or even hooves. It's a manicurist's worst nightmare. Let's look at some classic types.

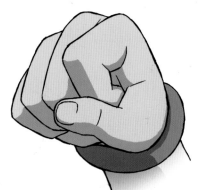

WOLFISH BEAST

Ruffle the fur on the outline, and add some sketch lines to indicate fur. The claws begin deep up in the fingertips; they don't rest on top of them like ladies' fingernails!

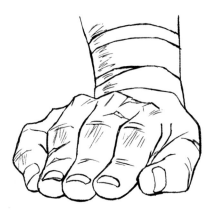

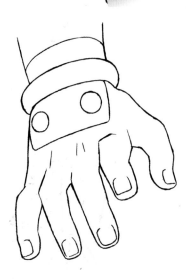

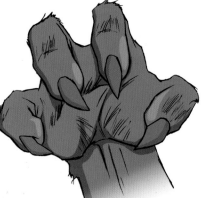

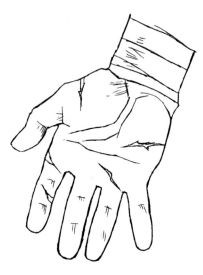

HEROIC HUMAN FIGHTER

Add some protective gear around the wrist to show that he's a warrior.

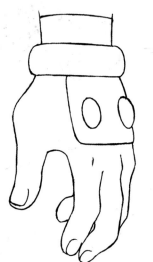

BRUTE OR ZOMBIE

These are fat, thick hands with wide palms and fingers that don't taper at the tips. The nails are square, and there are pronounced creases on the knuckles and palms. Bandages on the wrists give the character a supernatural look—reminiscent of hands on mummy characters.

ELEGANT OCCULT WOMAN

Accent the fingernails on particularly attractive or seductive female characters. Notice, too, how the pinkie is usually raised in a delicate position, adding femininity to the pose.

NORMAL WOMAN

The fingers are slightly shorter than the elegant occult woman's fingers, and the fingernails are only lightly indicated. This type of hand is for a more innocent type of character.

VAMPIRE

Vampires should have bony fingers, suggested by well-defined knuckles. You can also see the lines of protruding bones in the body of the hand itself. In addition, the fingernails should curl slightly.

The Body

The body can look challenging to draw, but it isn't. It's actually a clear and simple structure at its foundation. Forget all those books that tell you to start out with sketchy ovals for the rib cage and hips. What's that all about anyway? What pros really draw the body from that starting point? None that I know of. That method may make life easy for the author, but it doesn't help you a lot, does it? Instead, take a look at the true template for drawing the manga body here. Simple, straightforward, and effective. From this starting point, you can adjust the form to create all sorts of different characters.

SUPERNATURAL GUY: FRONT VIEW

With men, the torso is structured like this: wide top, narrower waist, narrower hips. You can, but don't have to, divide the torso into three sections: rib cage, midsection, and hips; or you can divide the torso neatly into only *two* parts: upper torso and lower torso.

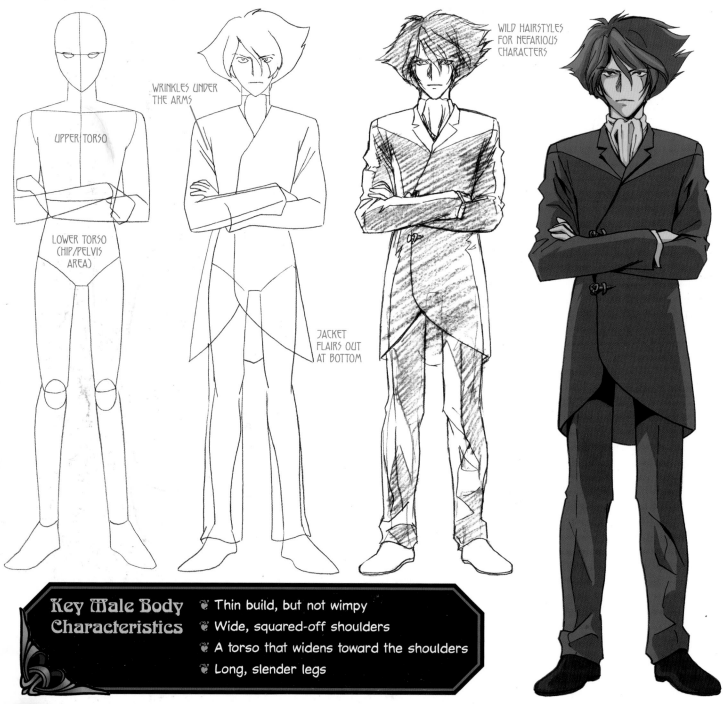

UPPER TORSO

LOWER TORSO (HIP/PELVIS AREA)

WRINKLES UNDER THE ARMS

JACKET FLAIRS OUT AT BOTTOM

WILD HAIRSTYLES FOR NEFARIOUS CHARACTERS

Key Male Body Characteristics
- Thin build, but not wimpy
- Wide, squared-off shoulders
- A torso that widens toward the shoulders
- Long, slender legs

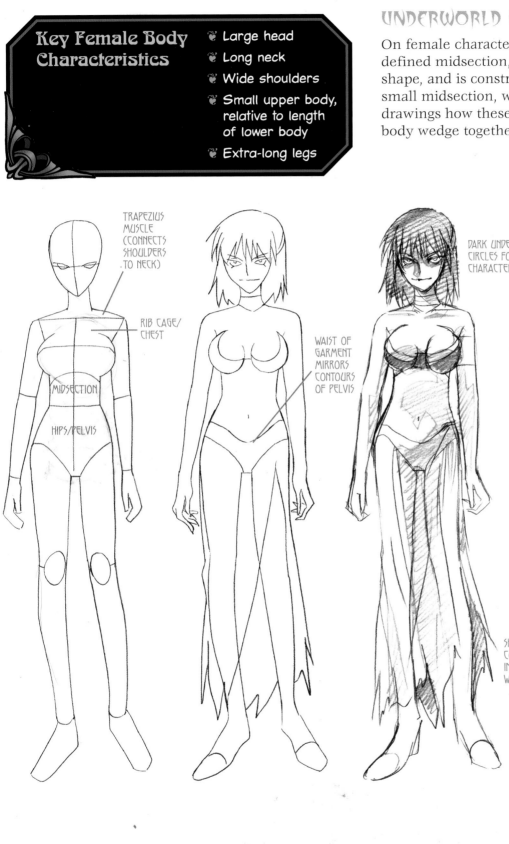

Key Female Body Characteristics

- Large head
- Long neck
- Wide shoulders
- Small upper body, relative to length of lower body
- Extra-long legs

UNDERWORLD WOMAN: FRONT VIEW

On female characters, the torso requires a defined midsection, because of the hourglass shape, and is constructed like this: wide top, small midsection, wide hips. Note in the drawings how these three sections of the upper body wedge together, "snapping" into place.

TRAPEZIUS MUSCLE (CONNECTS SHOULDERS TO NECK)

RIB CAGE/ CHEST

MIDSECTION

HIPS/PELVIS

WAIST OF GARMENT MIRRORS CONTOURS OF PELVIS

DARK UNDER-EYE CIRCLES FOR "BAD" CHARACTERS

SHREDDED COSTUME INDICATES WICKEDNESS

SUPERNATURAL GUY: SIDE VIEW

There are a few key details to note about how things appear in the side view. The neck tilts slightly forward; if it didn't, the stance would seem too stiff. Also, on the back of the body, the clothes hang slightly away from the underlying form. For example, the back of the jacket is off the pants (not resting on them), pushed outward by the buttocks.

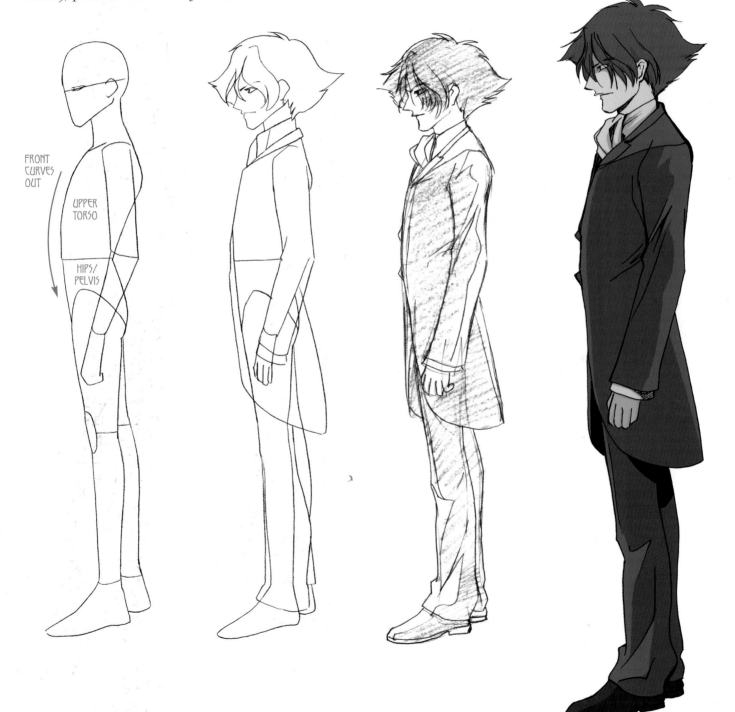

FRONT
CURVES
OUT

UPPER
TORSO

HIPS/
PELVIS

As in the previous example, here, too, the front of the torso is drawn on a convex curving line. In addition, note the hourglass curve of the back.

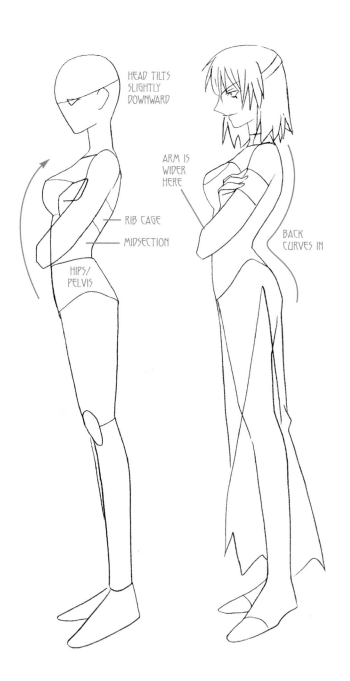

HEAD TILTS SLIGHTLY DOWNWARD

ARM IS WIDER HERE

RIB CAGE

MIDSECTION

HIPS/ PELVIS

BACK CURVES IN

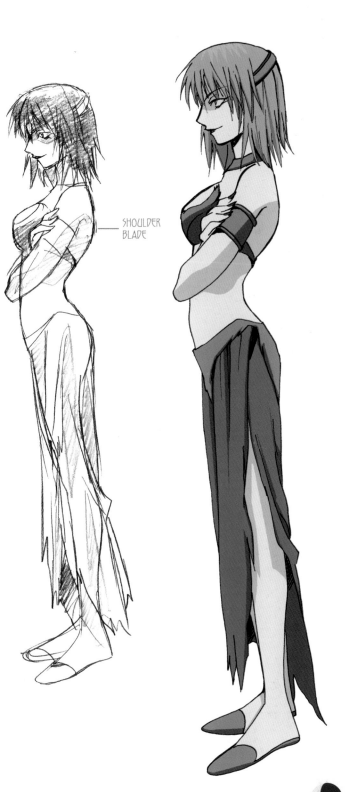

SHOULDER BLADE

SUPERNATURAL GUY: 3/4 VIEW

In the 3/4 view, the inward bend of the waist that you see in the side view (at the small of the back) is still visible. The natural leg positioning in a 3/4 pose is to have one leg "locked" straight at the knee and the other one relaxed and bent a little at the knee.

BEND

CUFFS
WIDEN
SLIGHTLY

LOCKED LEG

RELAXED LEG

VISIBLE
SHIRT CUFFS
ADD NICE
VICTORIAN
FLAIR

A Note about Drawing Clothes

Draw the entire lines of the garment in the construction steps—even the lines that you will eventually erase. This will help you keep everything well-aligned. In the example above, the jacket hemline appears to get the positioning right and then is erased as the cutaway jacket shape is finessed in the subsequent steps.

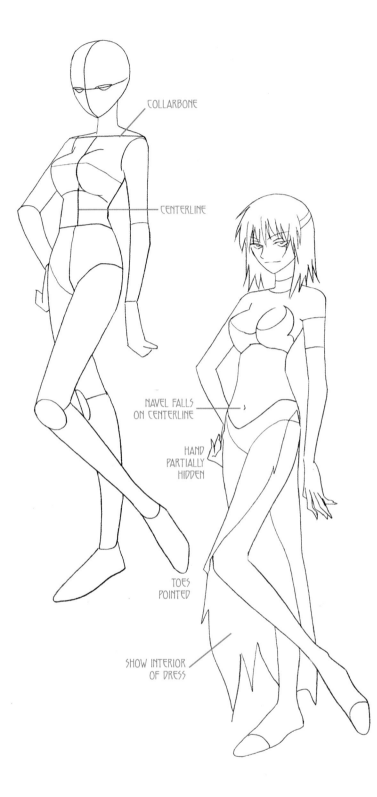

COLLARBONE

CENTERLINE

NAVEL FALLS
ON CENTERLINE

HAND
PARTIALLY
HIDDEN

TOES
POINTED

SHOW INTERIOR
OF DRESS

UNDERWORLD WOMAN: 3/4 VIEW

Instead of simply turning a standing pose so that it appears in a 3/4 view, create a playful attitude to go along with the 3/4 pose. Also, note the balance: The bent arm and bent leg are on opposite sides of the body.

Dynamic Poses

Good poses are not enough. I'm not belittling a well-drawn figure. Far be it from me to underestimate, or underappreciate, the skill required to draw a decent pose. But the pose must suit the character. And characters belong to specific genres, which all have certain distinctive postures.

A shoujo or more cute type of character has a bouncy, perky posture. Not so the troubled, wistful, romantic occult figure. Manga action characters pose triumphantly, but occult and horror characters are drawn with a sense of poetry and yearning and a tinge of sadness—all conspiring to create a compelling, haunting and bittersweet mood. The result is an atmosphere of mystery that surrounds the players in this nuanced genre.

Let's compare some ordinary poses with those typical of melodramatic occult-style characters and discover what makes them tick—and how you, too, can turn an ordinary pose into a supermoody one that pulls the reader in and doesn't let go.

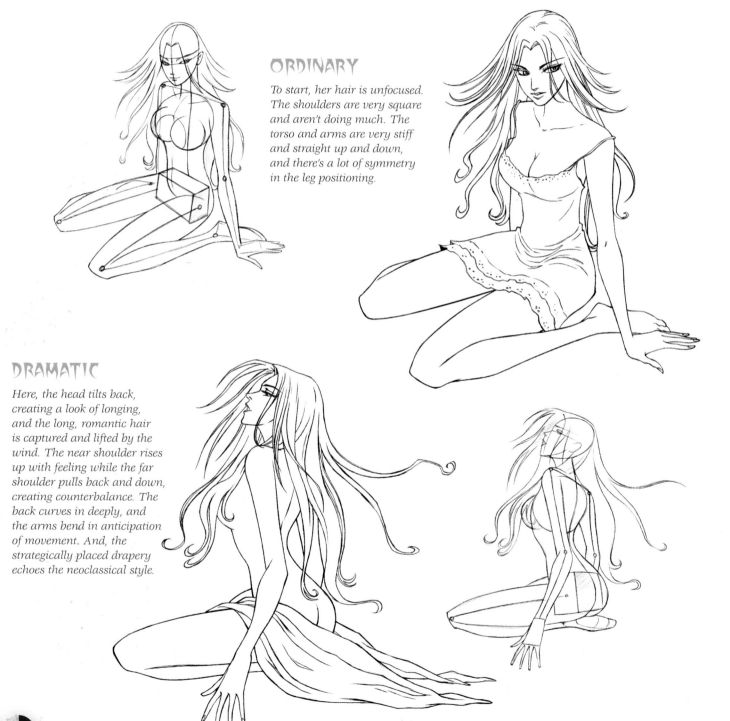

ORDINARY

To start, her hair is unfocused. The shoulders are very square and aren't doing much. The torso and arms are very stiff and straight up and down, and there's a lot of symmetry in the leg positioning.

DRAMATIC

Here, the head tilts back, creating a look of longing, and the long, romantic hair is captured and lifted by the wind. The near shoulder rises up with feeling while the far shoulder pulls back and down, creating counterbalance. The back curves in deeply, and the arms bend in anticipation of movement. And, the strategically placed drapery echoes the neoclassical style.

ORDINARY

This is a fine naturalistic pose, but the posture here shows no signs of inner struggle, no turmoil. This character's lack of internal conflict makes him a less interesting subject. In addition, feet pointing in opposite directions make him look like he's going to waddle like a duck. As far as getups go, it may be the trend to wear oversized, baggy clothes, but it is definitely not the look of a romantic troubadour. And, the straight, downward-blowing hair is not appealing.

DRAMATIC

Longer windswept hair is more appealing here, especially when coupled with delicate features and a reflective downward tilt of the head. The shoulders are square, but when coupled with the bent arms, the motion in the wide shirtsleeves, and the legs caught in mid-motion, the pose becomes dynamic. The body type is lean, with long arms and open hands with elegant fingers. The long legs taper, with the pointing toe making a single long line on the left-hand leg.

ORDINARY

The head is pretty perpendicular here, and even though she's reclining, the body falls along staid right angles and stiff straight lines. The hair is tame, and the skirt, while short, is plain.

DRAMATIC

By contrast, this reclining pose rapturous. It makes the character look like she's possessed —and perhaps she is. Her eyes are closed: Is a spirit speaking to her? Having the legs up creates a more provocative pose than having the legs down. The small of the back arches up in an alluring curve, and the foot is arched, too. The ruffles around the edges of the garment are characteristic of seductive characters, and the serpentine strands of hair are key to this dark genre.

ORDINARY

Overall, the figure is positioned in a flat angle—turned too far forward for this to be a nuanced pose. Though naturalistic, the leg position is awkward, and the sloppy, typical teen clothing does not create the dark and mysterious look needed for the occult and horror genre.

DRAMATIC

This pose has a feeling of all the character's weight "falling" or being pulled to the ground directly below him as he kneels humbly, calling on powers that lie beyond. The 3/4 angle is effective for conveying subtle emotions. The downward glance might imply that he is haunted by his past, and certainly adds mood. Working with this, having the arms fold in adds to this introverted moment. As for wardrobe, shrouding a figure in a dark cape is a telltale sign of the dark arts. Here, the cape spreads out, dominating the space around him. As an added touch, there's a decorative short cape with stitching details of occult symbols and warnings.

I'm a firm believer in teaching the basics, giving you the tools that you crave, to enable you to improve your skills so that they will take you to whatever level you want to reach. But I also believe in having fun. Not only do artists like to draw cool characters, but the reading public loves to *buy* manga graphic novels for the cool characters. In other words, if you're having fun, the reader is having fun, too. Therefore, we've got to create some great occult-and-horror character types—and there are all sorts. This chapter introduces the vampire and winged characters that are so popular in the manga occult-and-horror genre.

VAMPIRES WINGS & THINGS

Psycho, street trash, sociopath, troubled youth. Yeah, he's all of that. Then there's one more diagnosis that doesn't appear in the *Diagnostic and Statistical Manual of Medical Disorders*: Nosferatu. Sometimes, vampires double as outcasts, rebels, and punks. They live a lonely life, on the fringes of society. They're bands of misfits, cursed by their insatiable hunger. Don't push them too far, or you might just end up getting bitten.

Give this type of character an outsider's look: an earring, a gold chain, an opened shirt—anything that would make it impossible for him to get a corporate job—but nothing so in-your-face that it would turn him into an ugly, repulsive character (such as spikes in his chest or a large facial tattoo, for example).

NO SPACE

SHOW WIDTH OF THIS AREA

ARM OVERLAPS TORSO

KNEES, LIKE THE FEET, ARE AT TWO DIFFERENT LEVELS

FEET AT DIFFERENT LEVELS

LOOSE, OVERSIZED JACKET; NOTHING TAILORED AND EXPENSIVE

To create the bird's-eye angle, keep in mind these key points: Have the head overlap the body (don't leave space between the chin and the far shoulder). Show the area from the collarbone to the back of the neck. Have the near arm overlap the rib cage. And finally, position the feet at different levels, with the farther one appearing higher up than the near one.

Choosing the Angle

What does the angle of the pose say about the character? In the example on this page, it's not a neutral angle. It has a definite point of view. It tells us that we are looking *down* on the character in a condescending way. We are *better* than he is. And the character's eye contact with us tells us that he *knows* that we think less of him. It's humiliating for him, and his frown shows it.

Queen of the Vampires

The vampire queen is surrounded by her lavish and generous wings as if embraced by a luxurious cape. She must be enthrallingly beautiful and irresistibly seductive. Vampire women can be angry, aloof, cute, or cunning, but they are always attractive—and often downright gorgeous. Before you begin working on the ornate hairstyle and batlike wings, first draw an attractive human female figure in the pose you want. *Then* turn her into a vampire. Don't start her off as a vampire or you'll lose the importance of the figure drawing.

If you feel comfortable doing so, you can simplify the form by drawing the upper body as two sections: torso and hips. But if you have trouble with that, then go back to the original method covered in the first chapter, dividing the body into three sections: chest, midsection, and hips.

POINTS OF WINGS TURN INWARD

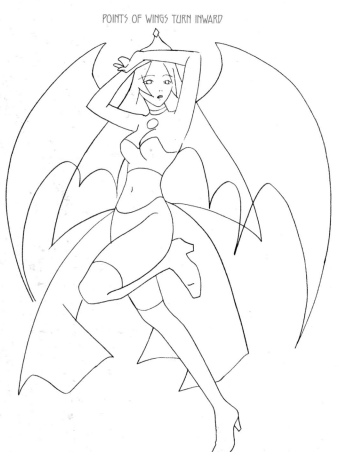

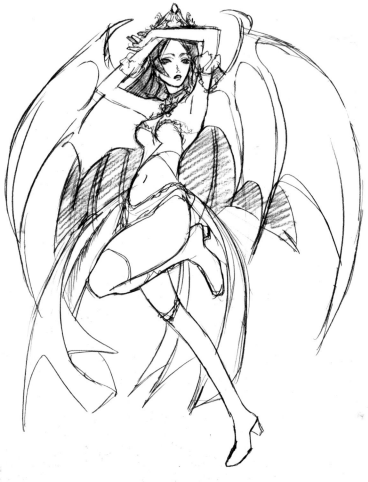

The high boots, like high gloves, are a good choice for evil characters. Provocative clothing is often worn by "bad girl" types. She does this to rattle the men she's trying to seduce, to get them off their game. She'll use every trick she has to steal a soul. A man must be very careful around her type. Remember, she has survived hundreds of years through her wiles and cunning. Although her face seems innocent, her heart is as cold as ice.

Hint: Fangs

Use fangs judiciously. *Don't overuse them*. If they appear on the character all the time, the character will look unattractive. Keep in mind that vampires want people to *forget* that they're after blood so that their potential victims will let down their guard. Lose the fangs for the most part, only bringing them out at just the right moment; that way, they retain the element of surprise.

Romantic Vampire

Pretty, not too gothic, and teenaged, the romantic vampire is like the girl next door. She's sweet, a little bit shy, and nice to talk to—and if given the right opportunity, she will kill you. Okay, so there are a few differences. The clue that's she's not actually the girl next door is her hair: Anyone who can trip over her own hairdo is of the dark realm.

CHIN TUCKED DOWN

ARM DEMURELY BEHIND BACK

ONE KNEE UP

ONE KNEE DOWN

FEET TOGETHER; TOES POINTED DOWN

HAIR CASCADES ALL THE WAY DOWN THE FIGURE

DRAPERY GATHERS AROUND FEET

INDIVIDUAL SWIRLS OF HAIR ARE ARTICULATED

The Colored Pencil Sketch

As you've no doubt noticed throughout the book so far, the second-to-last drawing steps often have some colored pencil marks. This is a rough suggestion for the coloring. Often, artists do some color "comps" (roughs) freehand, before the computer colorist does the final work. And many times, the artists who do the computer colors don't draw. So, if you're an artist who loves to draw but doesn't know how to do coloring on the computer, don't feel as though you have to stop drawing and learn all this specialized software. Different artists do different things. More often than not, publishers will have their own colorists. And many graphic novels are in black and white anyway. Covers, posters, and promotional materials are not, though. Still, 2-D artists are sometimes asked for guidance on the coloring, and often, all that's required are comps done with colored pencils or colored markers.

Glamour Vampire

The legend of the dashing vampire owes its roots to the story of Count Dracula. The noble count was born of aristocracy in a castle in Eastern Europe in the mountains of Transylvania. He was charming, elite, debonair, moneyed, and had a wicked secret: He was one of the living dead. Fast-forward to today: Some stories keep the aristocratic dress and the castle setting front and center. Some choose to leave them aside. But even the ones that toss them in favor of modernity often keep an archetypal remnant: the aristocratic cape and ascot and oversized shirt cuffs. The glamour vampire retains some of the dress from a time long ago, when *vampire* meant *nobility*, and the word *castle* meant *dungeon* for those who tempted fate.

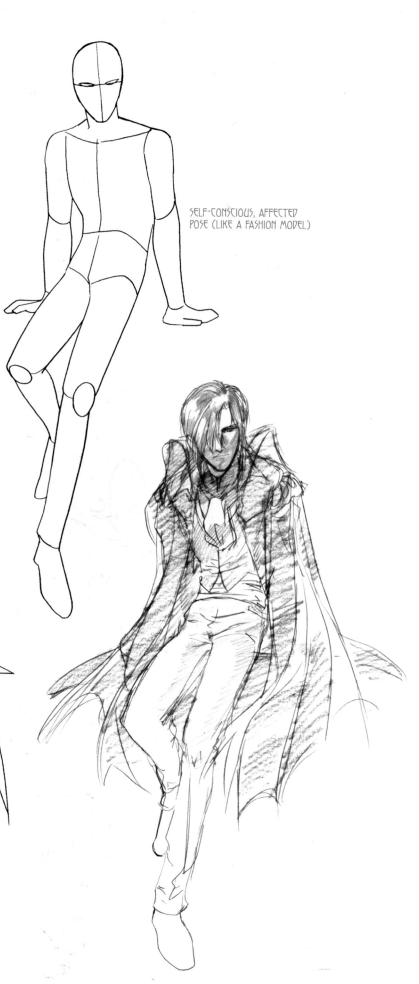

SELF-CONSCIOUS, AFFECTED POSE (LIKE A FASHION MODEL)

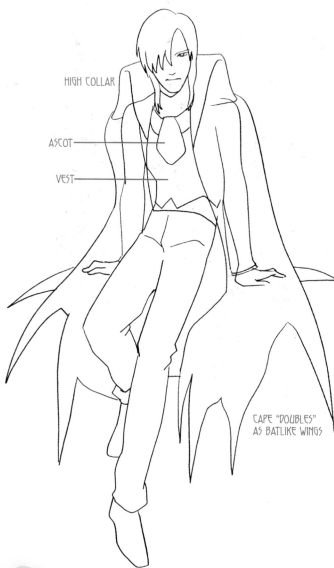

HIGH COLLAR

ASCOT

VEST

CAPE "DOUBLES" AS BATLIKE WINGS

Hint: Vintage

A vest is a good choice because it's a vintage look. Likewise, the high collar makes this character somewhat anachronistic. It makes you wonder, Just who is this guy? If his dress style is 150 years old, just how old is *he*? And how does he stay so young looking? There's only one way, folks. He needs a constant renewal of vitality to replenish his youth. And by now you must be able to guess how he gets it . . . and it ain't with vitamins.

Vampire Youth

Hey, we all gotta start somewhere. Why wait until you're out of high school to study the ways of darkness? Some manga girls get an early jump on it. They're vampirettes. At this stage, vampire tweens are quite similar to manga magical girls—it's just that they're in the occult genre, while the others are in the fantasy genre. They both like candy bars, boys, and music. When they get older, they'll realize just how stupid teenage boys are. That goes for the human girls, too.

BIG FOREHEAD FOR YOUNG, SHOUJOLIKE CHARACTERS

SLIGHT TORSO

KNEES TOGETHER FOR A CUTE TEEN STANCE

SAILOR-STYLE JAPANESE SCHOOL UNIFORM HAT

FUN BOOTS WITH FRILLS AT THE TOP

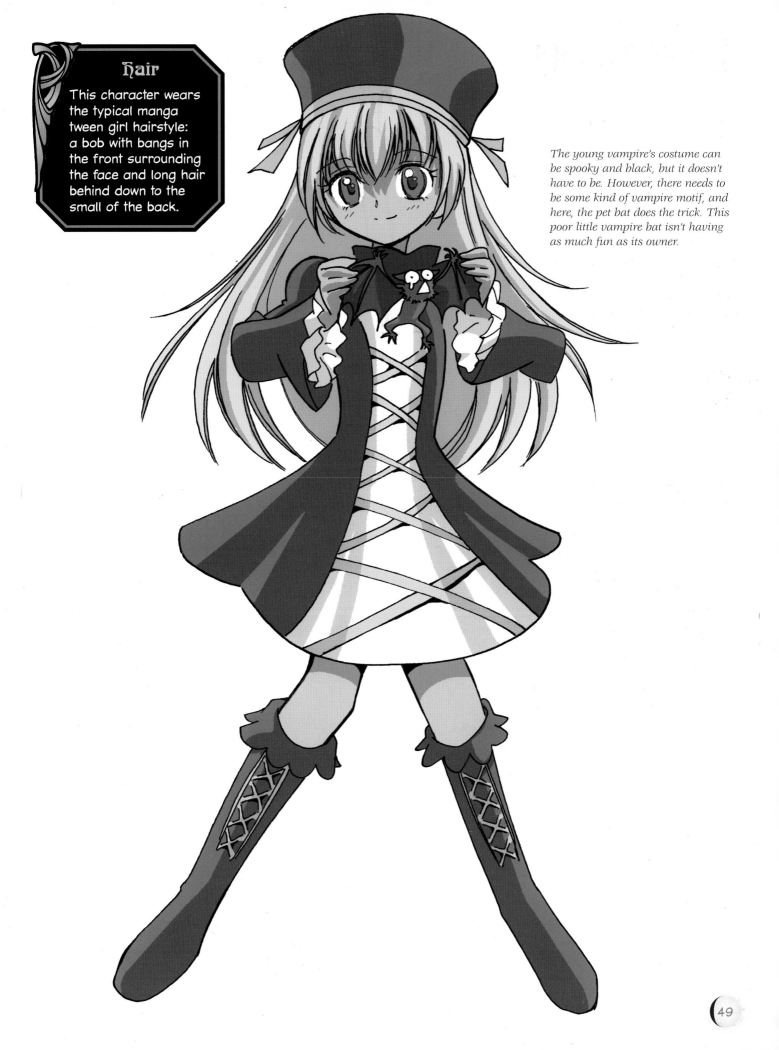

Hair

This character wears the typical manga tween girl hairstyle: a bob with bangs in the front surrounding the face and long hair behind down to the small of the back.

The young vampire's costume can be spooky and black, but it doesn't have to be. However, there needs to be some kind of vampire motif, and here, the pet bat does the trick. This poor little vampire bat isn't having as much fun as its owner.

Chibi-Style Vampire

Chibis are extremely cute and round little characters, and no one is terribly frightened by them. Sometimes, chibis are featured as vampires in humorous occult-and-horror stories. Often, these stories feature an all-chibi cast.

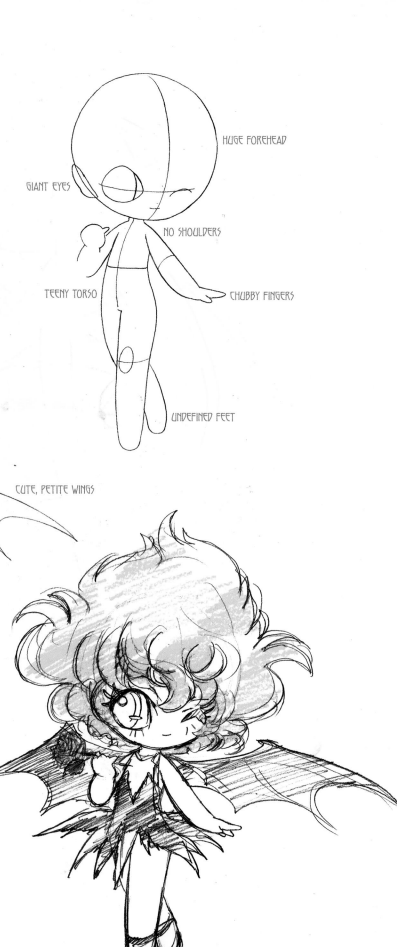

HUGE FOREHEAD

GIANT EYES

NO SHOULDERS

TEENY TORSO

CHUBBY FINGERS

UNDEFINED FEET

BIG HAIR

CUTE, PETITE WINGS

LEAFY FAERIE DRESS POPS OUT AT WAISTLINE

Hint:
Chibi Faces

A wink of the eye is a winning look for cute chibi characters, and don't be stingy on the eyelashes. Chibis have large eyes and huge heads relative to their body size. They also have tiny mouths . . . unless they have a sudden meltdown—then, they can have huge mouths and extreme expressions! And, chibis usually have no noses at all.

A Wing and a Prayer

Believe me, you'll need to pray if you see these characters coming at you. The wings of occult-and-horror characters never look static. They are expressive appendages. They can fold up, envelop a character, or spread out to span an entire page.

Wings come in many varieties. The most popular is the skin/skeleton type based loosely on bat wings but borrowing, to some degree, from prehistoric birds like the pterodactyl, which was a flying predator. Some wings have a claw accent, like a "thumb," at one joint, while others have layered feathers. This style is used more on "dark angel" character types than on vampires.

Wings also provide added degrees of grace, power, and stature to an occult figure. They increase the overall height of the character and serve to create a much longer shadow, which can be cast upon those standing nearby with intimidating results.

Unlike with other parts of the body, for which you begin by drawing the *overall outline*, with wings you should always start with the *simplified skeleton*. That's because the skeleton is often a visible part of the wing. The angles will be lost if you get too vague in the wing anatomy here. Don't get too cartoony. The good news is that once you understand the basic anatomy of the wing—and it's not that difficult—it will all fall into place.

SKIN WINGS (FOR VAMPIRES AND DEMONS)

"FOREARM" "HAND"

"UPPER ARM"

"SHOULDER BLADE" "ELBOW" THE SPINES ARE THE "FINGERS"

THERE'S SKIN ABOVE THE ELBOW "THUMB"

BOTTOM OF WING DOES ATTACH TO ACTUAL ELBOW JOINT

SKIN BETWEEN SPINES CURVES INWARD

WINGS ABOUT TO UNFURL

A powerful way to introduce a dark, winged antagonist is with the wings completely closed around the figure. Then, panel-by-panel (in a comic book format), allow them to unfurl slowly, revealing the hideousness inside. This adds mystery and suspense. It also bathes the character in shadow.

FOLDED

OPEN

FULLY OUTSTRETCHED

FEATHERED WINGS (FOR DARK ANGELS)

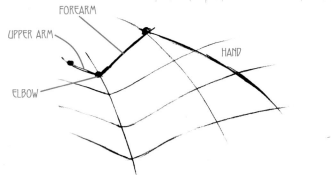

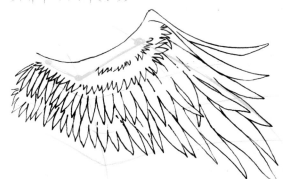

LAYER FEATHERS
HORIZONTALLY ACROSS
ENTIRE WINGSPAN

CURVING THE WING TIPS INWARD

This is a small but extremely important hint that will add a professional touch to all of your winged characters: Turn the tips of the wings inward. This is a cool accent that imparts a sly, cunning look. But it does even more than that: It suddenly transforms the wings from purely decorative or utilitarian devices into active appendages that move in response to a character's emotions and attitudes. And that's the key to a great, wickedly alluring character.

WING POSITION

The position of the wings indicates in which direction the fantasy figure is flying. In addition, when you show off the "big stretch" in the bat-style wings, nothing is more impressive. A set of these huge, bony flappers spreading out wide in each direction is sure to make even the bravest soul swallow hard. Take a look:

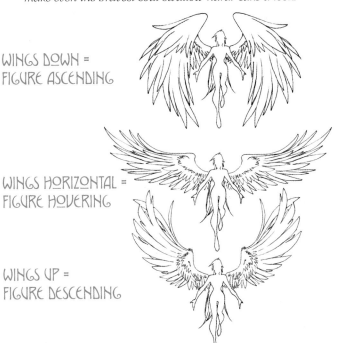

WINGS DOWN =
FIGURE ASCENDING

WINGS HORIZONTAL =
FIGURE HOVERING

WINGS UP =
FIGURE DESCENDING

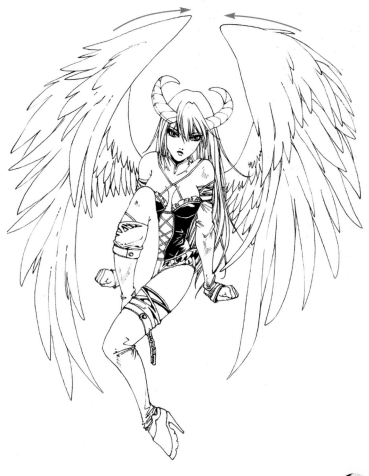

When One Wing Style Is Not Enough

These are examples of some of the many wing varieties you can come up with. Wings are like individuals: Each pair is different. You should approach them with the same creativity you bring to any other part of your character's design.

Sometimes, the wings will mirror the character's type. Sometimes, they'll go "against type," meaning that they'll be drawn in a style that seems to be the opposite of the character's style. These are often the most interesting wings. Imagine a shoujo-style character with gothic wings. It's certainly not run-of-the-mill.

AGAINST TYPE (GOTHIC GIRL, MECHA WINGS)

DARK FEATHERS

DEVIL WINGS

GOTHIC-CREATURE WINGS

Seductive Poses for Women with Wings

Here's the little secret that the manga pros don't want you to know: One of the main reasons wings are added to female occult characters is because they add sex appeal. Think about it: How often do you really see these intoxicatingly beautiful vampires actually fly? How about never? So, what are the wings for? To create a wicked ambiance? Yeah. To carve out the occult identity? Sure. To make the characters breathtaking to behold? Ding!

Now, as a comic book artist, I want you to tattoo this on your brain: *Pretty drawings are not enough.*

Without engaging, seductive poses, even pretty women will become boring after a few panels. On the following pages are examples of poses with flair—poses that communicate with the reader, creating almost an intimate moment. You'll see what I mean.

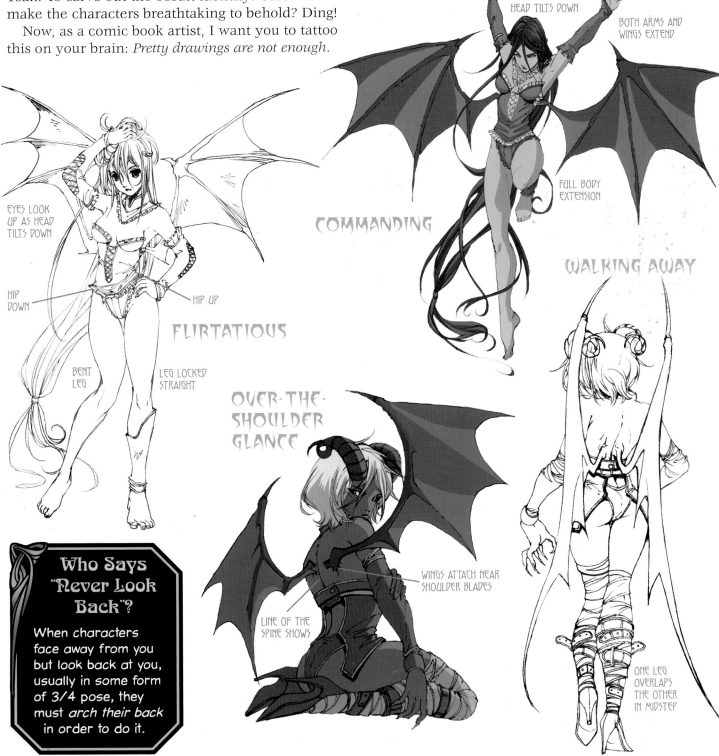

HEAD TILTS DOWN

BOTH ARMS AND WINGS EXTEND

FULL BODY EXTENSION

COMMANDING

WALKING AWAY

EYES LOOK UP AS HEAD TILTS DOWN

HIP DOWN

HIP UP

FLIRTATIOUS

BENT LEG

LEG LOCKED STRAIGHT

OVER-THE-SHOULDER GLANCE

WINGS ATTACH NEAR SHOULDER BLADES

LINE OF THE SPINE SHOWS

ONE LEG OVERLAPS THE OTHER IN MIDSTEP

Who Says "Never Look Back"?

When characters face away from you but look back at you, usually in some form of 3/4 pose, they must *arch their back* in order to do it.

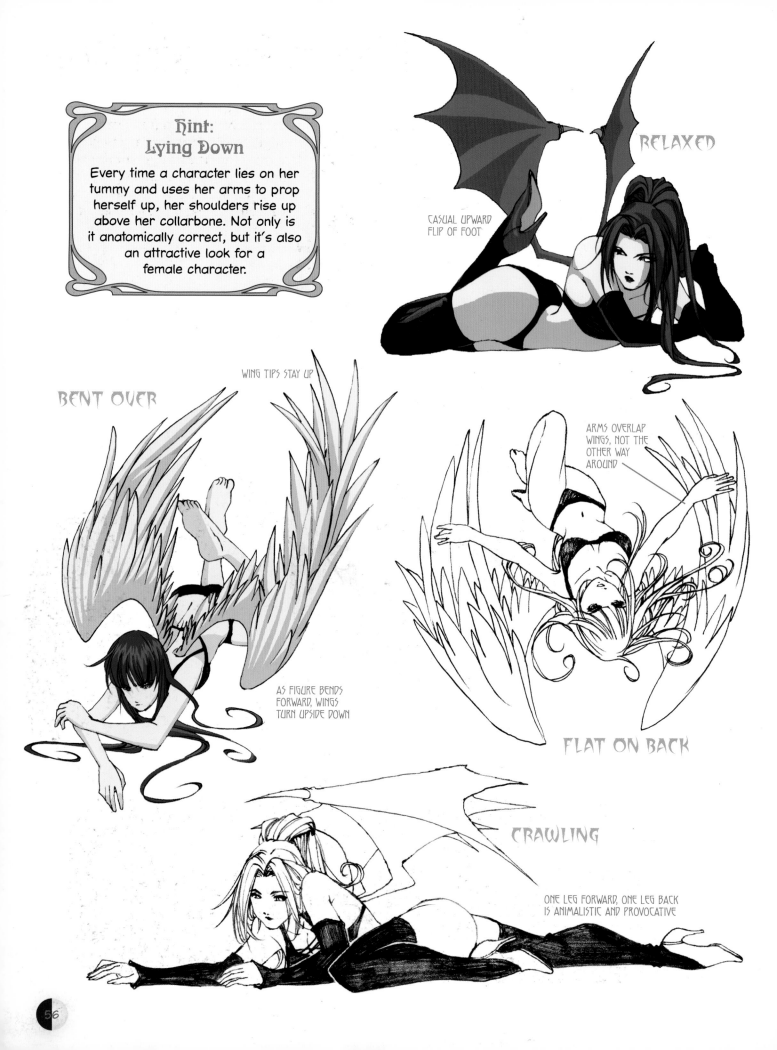

**Hint:
Lying Down**

Every time a character lies on her tummy and uses her arms to prop herself up, her shoulders rise up above her collarbone. Not only is it anatomically correct, but it's also an attractive look for a female character.

RELAXED

CASUAL UPWARD FLIP OF FOOT

BENT OVER

WING TIPS STAY UP

AS FIGURE BENDS FORWARD, WINGS TURN UPSIDE DOWN

ARMS OVERLAP WINGS, NOT THE OTHER WAY AROUND

FLAT ON BACK

CRAWLING

ONE LEG FORWARD, ONE LEG BACK IS ANIMALISTIC AND PROVOCATIVE

Wings as Expressive Tools

The wings can be almost as expressive as the figure itself. The subtle positioning of the wings can underscore the attitude of the pose. Even in poses in which the character is doing nothing overtly seductive, the wings make the figure emotive.

WING COVERS HER LIKE
A COMFORTING BLANKET
AND STAYS ALOFT

HEARTBROKEN

ENRAPTURED

ENDS OF FEATHERS
LIFT, PULLED BY
MYSTERIOUS FORCES

WINGS CURVE AROUND
THE FORM, FRAMING IT

"COME HITHER"

Wings Just Because

We've seen how useful wings can be in creating attitudes and emotions for characters. However, sometimes you give a character huge, oversized wings just for the sheer look of it. The only problem is that huge wings are too big to be moved around a lot, certainly not with the subtleties that can reflect the nuances of different moods. With the exception of the classic spread-wing pose (always impressive), more often than not, huge wings tend to get in the way. You have to find inconspicuous techniques for shifting their positions so that they give breathing room to the figure itself. You don't want them crowding or cutting off the character.

Hunters of Vampires

Almost as popular as the Lords of Evil, and sometimes even outshining them, are the true-blue, intrepid souls who risk everything to save us all from the rule of darkness. I'm speaking, of course, of the characters who hunt vampires, werewolves, demons, and other nefarious beasts and creatures. These fighters vary in age from young-teen (shoujo) to older-teen (bishoujo/female and bishounen/male) characters. It's an accepted convention in manga that shoujo- and bishoujo-style hunter characters can coexist with the gracefully drawn vampire types in the occult-and-horror genre.

SHOUJO WARRIOR KNIGHT

The most popular vampire fighter of them all is the shoujo boy warrior. His body is young, not angular with hard muscles. His head is on the large side—a sign of youth. The torso is not yet long and lean; that occurs with maturation.

He wears lots of "stuff," since he's fighting a demon that wants to kill him! Yet, you want him to look dynamic, even with all those forearm, elbow, shoulder, knee, and shin guards. If he becomes too bulky, he'll look like a little porker, and you don't want that. So, use the outline of his body as the outline of the clothing. Occasionally, folds and loose material pop up. But if you want to make the character look sleek—even with a lot of gear on—generally, skintight clothing is the way to go.

Impact Lines

In the third step, energy and impact lines are added. This is *not* a substitute for dynamic posing, but let me tell you, it really helps to fire up a scene! Take a look at the different types of lines. And note that the ponytail also serves to create a line of action as it whips around to convey extreme movement.

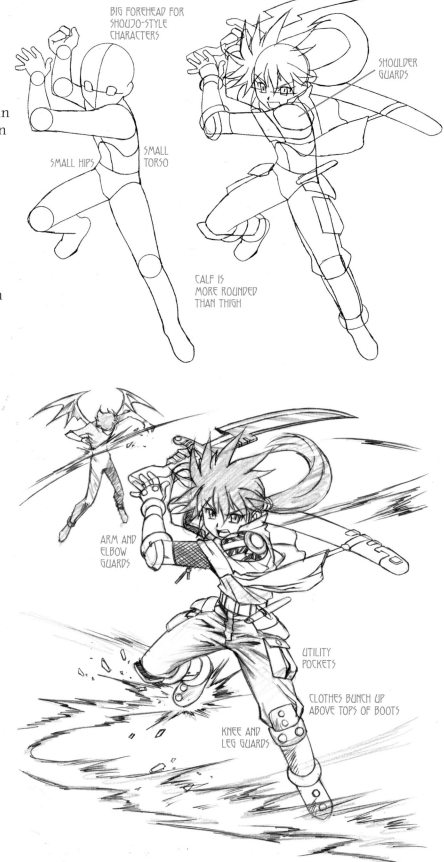

BIG FOREHEAD FOR SHOUJO-STYLE CHARACTERS

SHOULDER GUARDS

SMALL HIPS

SMALL TORSO

CALF IS MORE ROUNDED THAN THIGH

ARM AND ELBOW GUARDS

UTILITY POCKETS

CLOTHES BUNCH UP ABOVE TOPS OF BOOTS

KNEE AND LEG GUARDS

SLASH LINES

SLASHING
EFFECT

Hint:
Action Poses

If this character actually froze
in this pose, he would fall on
his face, because he's leaning
forward. But that's what you
want in an action pose.
Remember: Get your
characters to lean into their
actions. Perfectly balanced
poses are too static
for action scenes.

STOMPING MOTION LINES

WRAPAROUND SPEED LINES

SHOUJO REVENGE FIGHTER

Whereas occult figures strike a slinky pose, the good-fighter type of character assumes a much more straightforward, heroic stance. The feet are spread apart and symmetrically positioned, which translates into an inner strength and stability. Elbows in with guns pointed at opposite directions is a classic look for an experienced gunfighter. If you've drawn this character well, she will hold up and command the reader's attention when you put her into a full-page scene. Even though she's still young, her determination and fighting spirit will fill the reader with confidence.

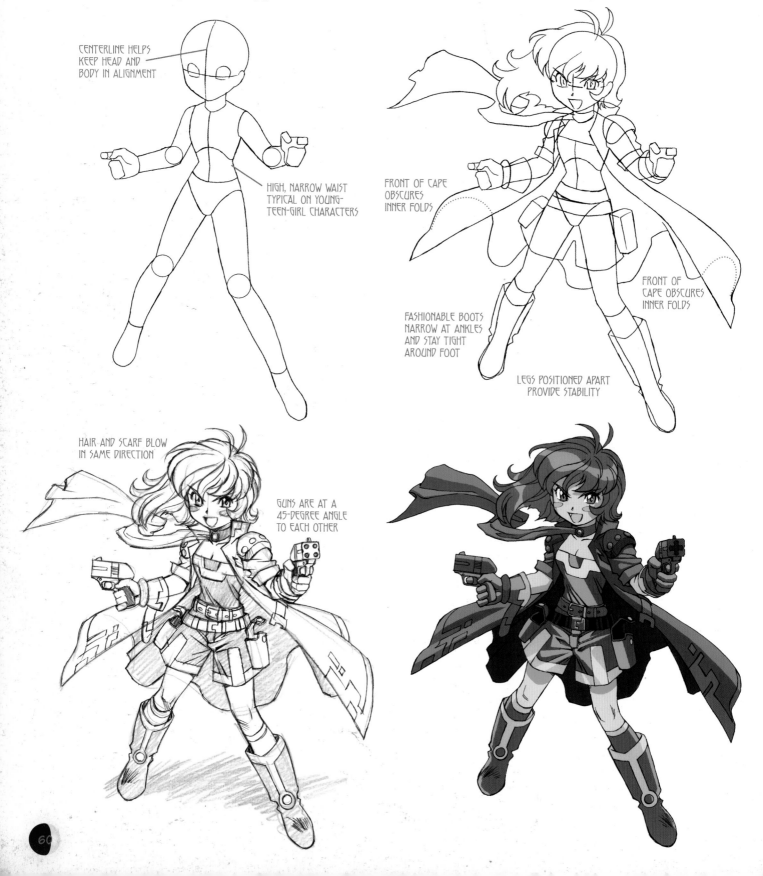

CENTERLINE HELPS KEEP HEAD AND BODY IN ALIGNMENT

HIGH, NARROW WAIST TYPICAL ON YOUNG-TEEN-GIRL CHARACTERS

FRONT OF CAPE OBSCURES INNER FOLDS

FRONT OF CAPE OBSCURES INNER FOLDS

FASHIONABLE BOOTS NARROW AT ANKLES AND STAY TIGHT AROUND FOOT

LEGS POSITIONED APART PROVIDE STABILITY

HAIR AND SCARF BLOW IN SAME DIRECTION

GUNS ARE AT A 45-DEGREE ANGLE TO EACH OTHER

Hint: Composition

Note how the figure in the foreground *frames* the fighter. The opponent's shoulder guard and the head wind around to form a U that encircles the girl, leading the eye to the middle of the page, right where we want it! Framing is an effective compositional tool.

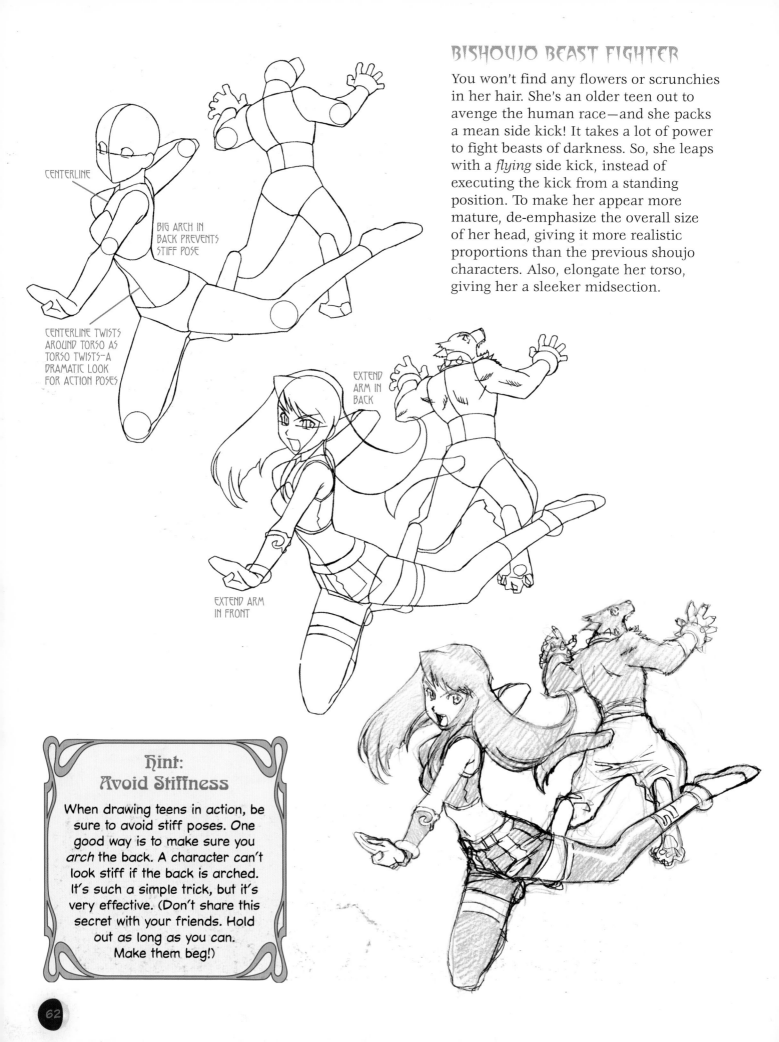

CENTERLINE

BIG ARCH IN BACK PREVENTS STIFF POSE

CENTERLINE TWISTS AROUND TORSO AS TORSO TWISTS—A DRAMATIC LOOK FOR ACTION POSES

EXTEND ARM IN BACK

EXTEND ARM IN FRONT

BISHOUJO BEAST FIGHTER

You won't find any flowers or scrunchies in her hair. She's an older teen out to avenge the human race—and she packs a mean side kick! It takes a lot of power to fight beasts of darkness. So, she leaps with a *flying* side kick, instead of executing the kick from a standing position. To make her appear more mature, de-emphasize the overall size of her head, giving it more realistic proportions than the previous shoujo characters. Also, elongate her torso, giving her a sleeker midsection.

Hint: Avoid Stiffness

When drawing teens in action, be sure to avoid stiff poses. One good way is to make sure you *arch* the back. A character can't look stiff if the back is arched. It's such a simple trick, but it's very effective. (Don't share this secret with your friends. Hold out as long as you can. Make them beg!)

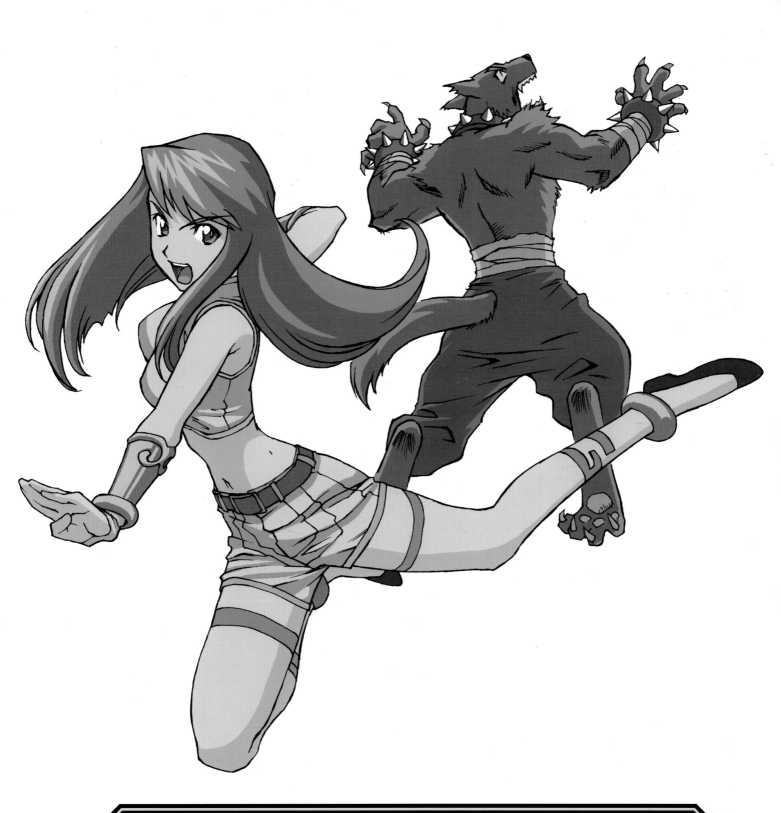

Momentum & Primary Action vs. Secondary Action

The momentum of the pose plays a big part in the direction in which you draw the hair. To be convincing, the placement of the hair should relate *correctly* to the momentum of the pose. This adds to the feeling of action, preventing it from having just a scattered, random look.

In this image, the girl moves to our left. This is the *primary action*, the momentum. The movement of her hair is a *secondary action*, meaning that it follows a beat behind the primary action (this is a basic animation principle). As a result of this *drag behind*, the hair sweeps to the *right*. If she were moving to the *right*, the hair would sweep to the *left*.

Bishounen-Style Vampire and Beast Trainer

One of the most skilled characters in this genre is the trainer of beasts. He can stare down a demon and make it do his bidding. Few know his secrets.

With the bishounen-style hunter, we move up in age. This is a more elegantly attired male character. He's tall, lean, and lanky. Note the difference between his getup and the outfits of the shoujo-style characters we've just seen. The more aristocratic and eighteenth century the clothing, the more clothes the character should wear. This holds true for both male and female characters. In the days of yore, people wore not only different styles of clothes, but lots more of it.

SHARP JAWLINE

Eyeglasses are a popular, cool look on Japanese comic book characters, whereas on American characters they're considered nerdy unless they're sunglasses.

LEG PROPORTIONS ARE EXTRA LONG

"Bumpy" hair is an authentic manga style that few American artists try to emulate. Give it a shot!

THE BEST LOOK FOR A TRENCH COAT: WITH BOTTOM FLARING OUT

64

Hint: Floating

Can you tell which leg the
weight is on here? No? Good!
Because that's how you know he's
floating. The weight of the body
isn't being propped up by either leg.
Both knees are relaxed and bent.
Even characters who don't fly
can be drawn to look like they're
floating. It's a dramatic device that
emphasizes a pose or a moment
in time, like the introduction of
a character who arrives
to save the day.

OTHER OCCULT CHARACTERS

Once you step into the world of occult and horror, you find a lot more than vampires. Darkness comes in all shapes and sizes. Even innocent-looking children are really creatures of the night out to get you. Many horror characters are bewitched beings in human form. And, if you come across a samurai while you're in this dark, misty place, don't ask him for help.

Doll-like Ghost Girl

Any haunted child with big eyes makes for a very spooky character. Making someone who seems so innocent look so creepy gives the audience the chills. Dress her up in something old-fashioned, with curls, lace, and lots of flounces. Then, add a touch of the macabre. Sometimes, it's dark circles under the eyes. Other times, it's a disquietingly gray tone to the skin. What makes this girl so alarming is her stuffed toy rabbit—complete with hangman's noose wrapped around its neck. Her "comfort" toy.

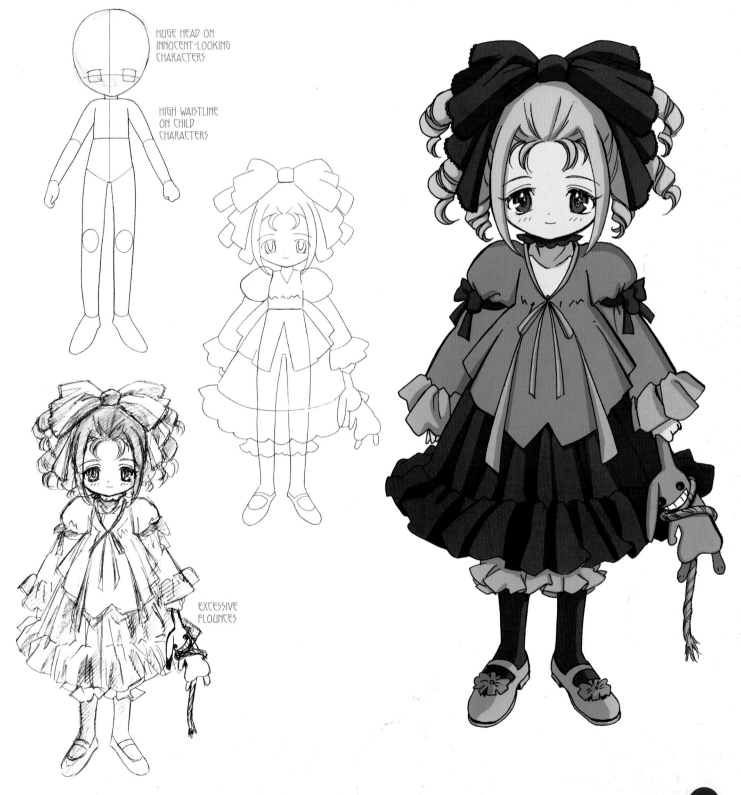

HUGE HEAD ON INNOCENT-LOOKING CHARACTERS

HIGH WAISTLINE ON CHILD CHARACTERS

EXCESSIVE FLOUNCES

Monster Assassin

When you have an infestation of monsters, he's your man. His motto is "Why screw around with knives and stakes when you can blow a watermelon-size hole through a zombie's head?" And some of his guns pack time-delayed explosives instead of bullets. They lodge into the skull—tick, tick, tick and then *KA-BOOM!!* Splat—all over the lawn. It's not pretty, but it gets the job done. Call him if you need him. He's in the yellow pages. Of course, keep in mind that while he might sound like a good guy—and maybe was once—he has grown to enjoy killing so much that he has become as warped and violent as those he hunts.

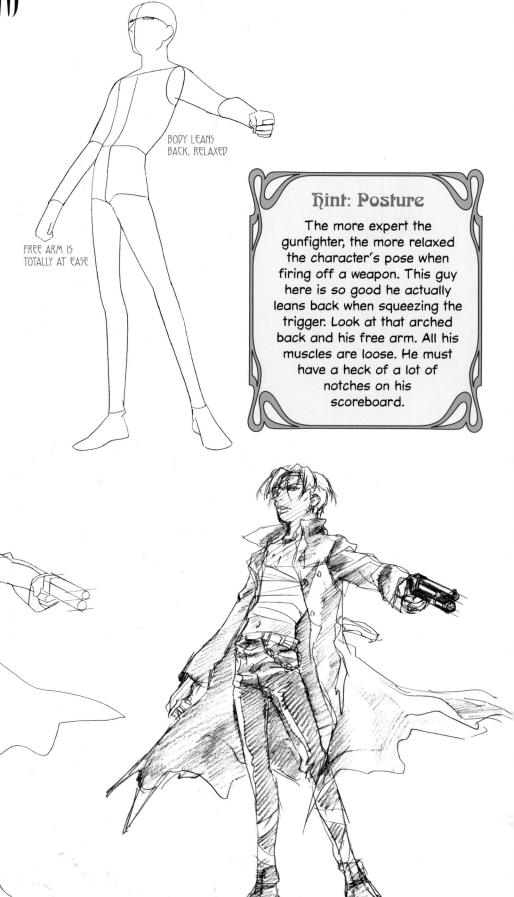

BODY LEANS BACK, RELAXED

FREE ARM IS TOTALLY AT EASE

Hint: Posture

The more expert the gunfighter, the more relaxed the character's pose when firing off a weapon. This guy here is so good he actually leans back when squeezing the trigger. Look at that arched back and his free arm. All his muscles are loose. He must have a heck of a lot of notches on his scoreboard.

How to Aim & Shoot

You can have your character shoot a weapon in one of three directions: upward, horizontally, or downward. A downward aim is the most confident, powerful way to shoot. It says, "I'm in command." It also lets the shooter eyeball the victim from above—an angle of superiority.

Additionally, a downward-pointing arm holding the gun cuts a clean diagonal. It's far more dynamic than if the arm were held horizontally.

Human-Animal Hybrid

Another popular motif throughout the horror genre—and one that dates back to the 1800s—is the idea that men of science who experimented with combining the human and animal kingdoms were playing God—and would suffer for their arrogance. This experimentation was crossing the line into the very nature of good and evil.

In these stories about splitting the human soul into good and evil, evil flourished. It released something uncontrollable. This theme evolved to where we are in narratives today: The act of "splitting" has sometimes been abandoned as a story device, but the hybrid human-animal form remains. And it's evil.

Although you see it done sometimes, it's best not to mix animal types—for the sake of clarity. It's best to choose one animal type and combine it with a human. A bird of prey, a lizard, or a predator of any sort is a good choice.

LONG, SLINKY CURVE CREATES AN ANIMAL-LIKE APPEARANCE

LEG DISPLAYS BIRD LEG ANATOMY WHEN BENT

BIRD FOOT IS EXTREMELY LONG

ELONGATED WRIST TO MIMIC ANIMAL ANATOMY

TOES SPREAD OUT IN A TRIDENT FORM

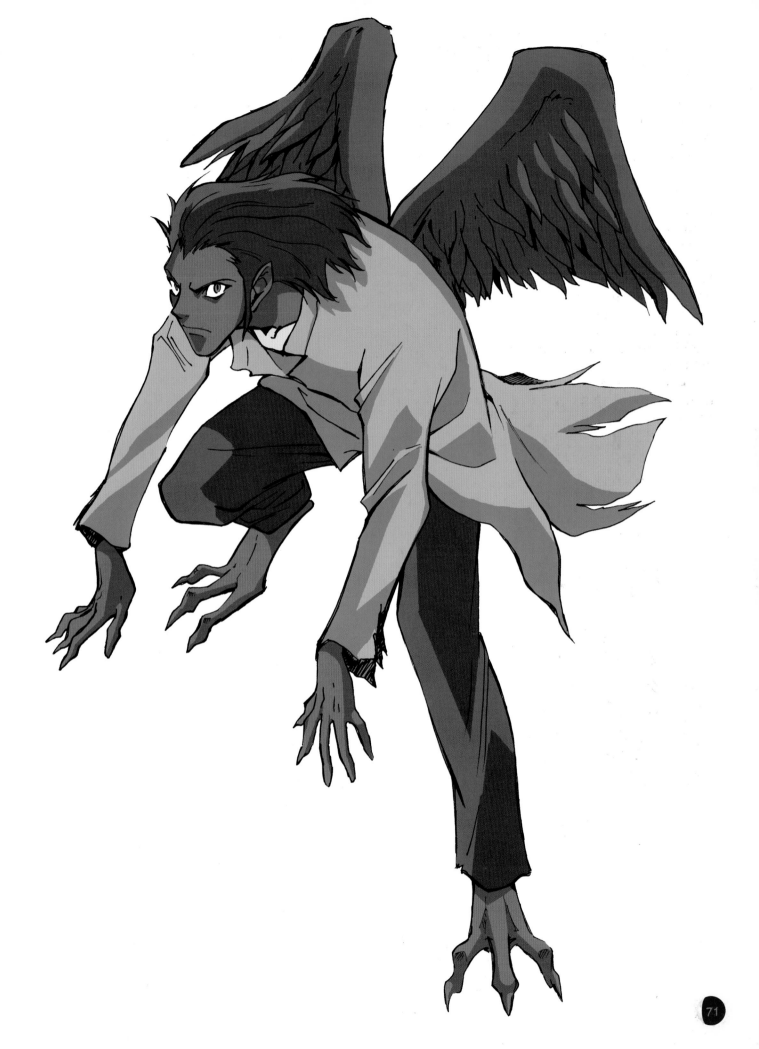

Occult Cat Girl

Cat girls are already a little weird, although they remain very popular characters. And though they originally belonged to the shoujo style of manga, it doesn't take much to turn them into full-fledged occult figures. A few occult symbols and a cloak and hood are all that are needed. Being of the animal kingdom, this creature would be found deep in some enchanted forest, perhaps serving as a guide to help lost souls find their way out. And, by successfully doing so, she might break the spell that has kept her in bondage and thereby resume her natural, beautiful human form.

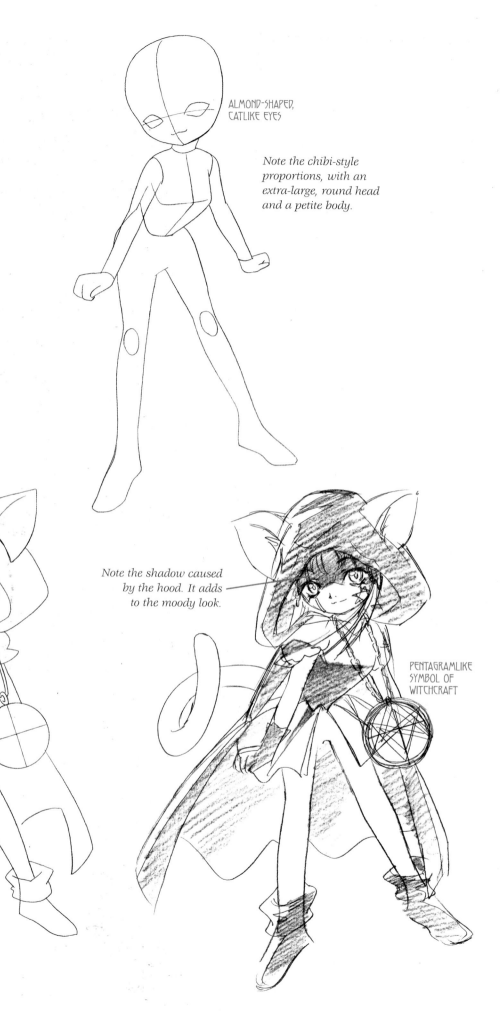

ALMOND-SHAPED, CATLIKE EYES

Note the chibi-style proportions, with an extra-large, round head and a petite body.

GIANT CAT EARS

MYSTERIOUS HOODED CAPE

Note the shadow caused by the hood. It adds to the moody look.

PENTAGRAMLIKE SYMBOL OF WITCHCRAFT

Hint: The Importance of Accessories

Matching gloves and boots put this character squarely in the occult genre. Were she to have bare paws and feet, with claws showing, she would look more like an "anthro" (an animal character with a human personality).

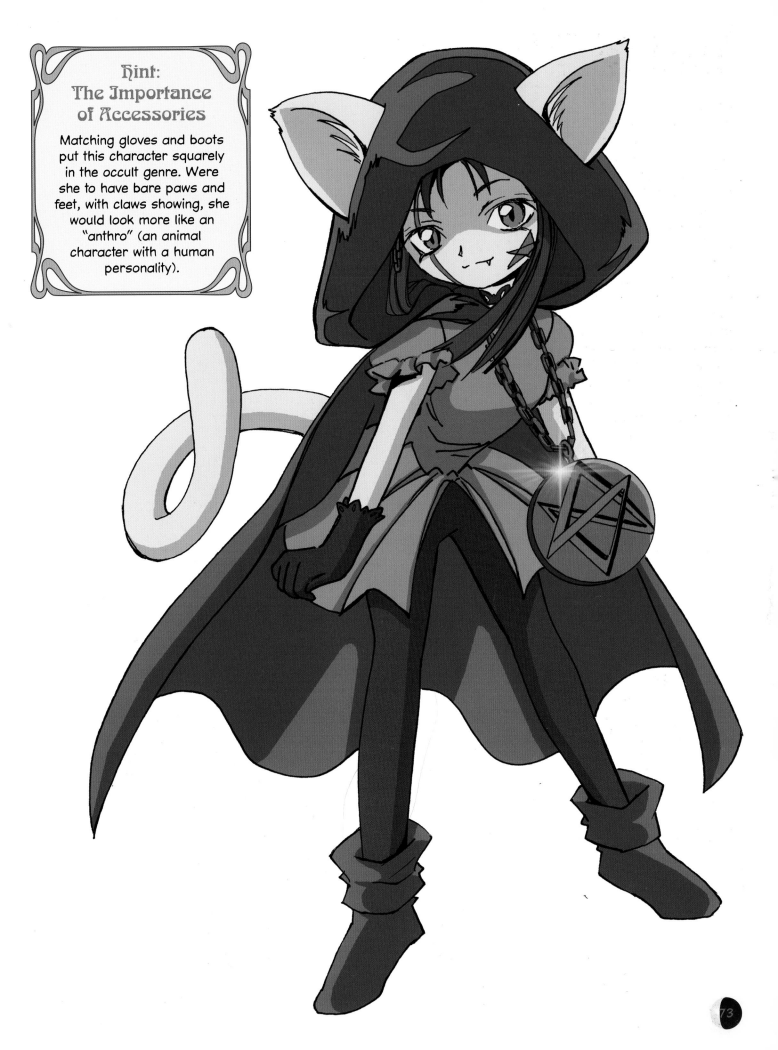

73

Cowardly Supplicant

There's always one suck-up in a group, and this guy's it. When he finds out that someone in his gang is a vampire, he quickly reasons that he might end up as a blue plate special. So, he immediately kisses up to the vampire, turning into his personal butler in order to get the monster to spare his hide. What an unctuous personality. To reflect this, his posture and pose must be craven. Heck, he's already on his knees! His chest should be curved inward and his limbs spindly. Not exactly a beaming example of manhood. He looks up from under his eyelashes, sort of sideways, at his master—hoping, with a half-smile, for mercy and favor. He may even get some—for the moment. But just when he feels safe and secure, he'll be struck down. There's no loyalty when you sign an oath with the devil.

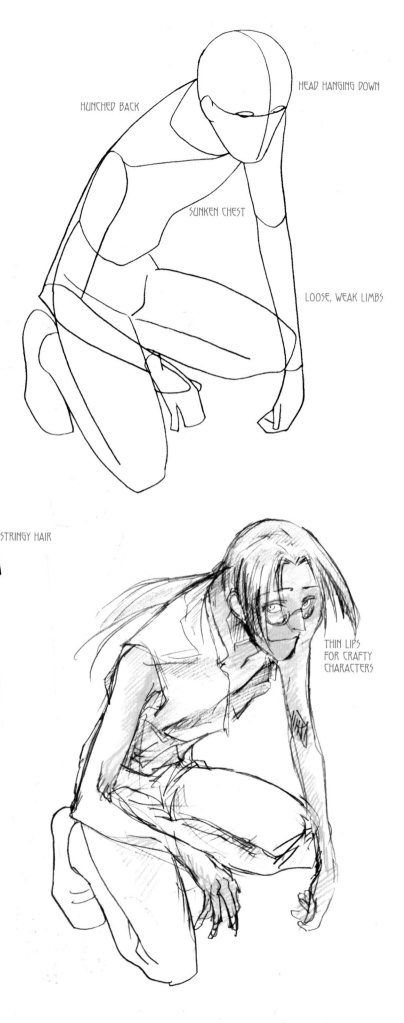

HUNCHED BACK

HEAD HANGING DOWN

SUNKEN CHEST

LOOSE, WEAK LIMBS

STRINGY HAIR

THIN LIPS FOR CRAFTY CHARACTERS

LONG, THIN, BONY FINGERS

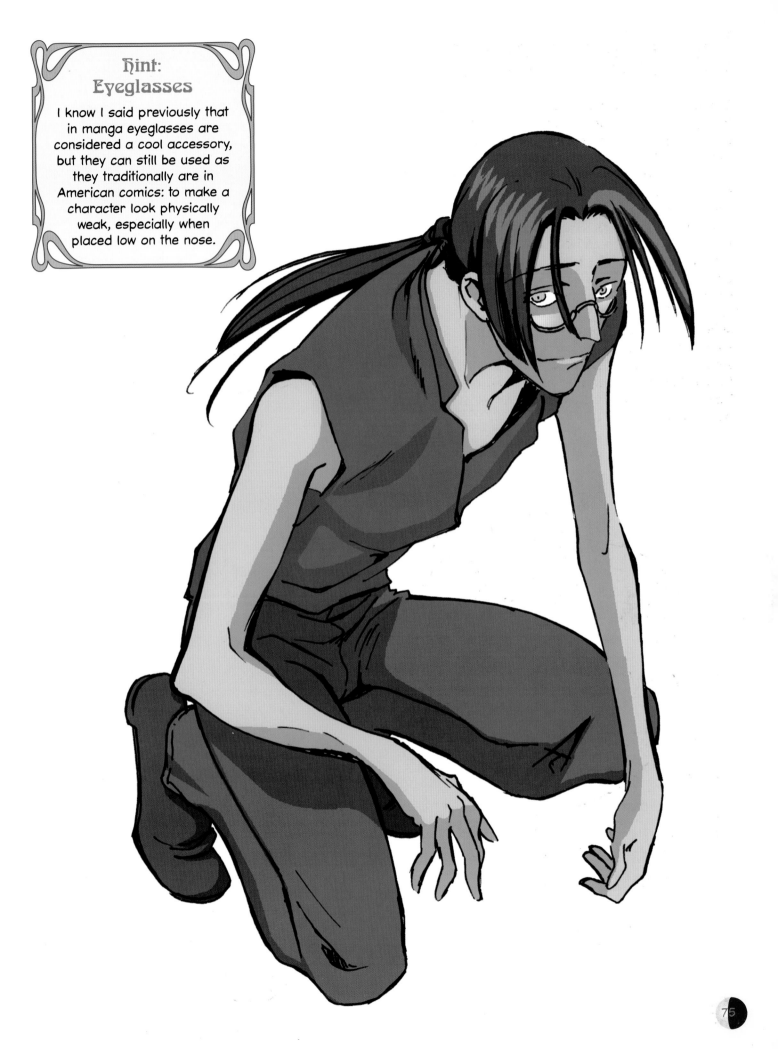

Exterminator Samurai

Samurai are generally thought of as noble: the Eastern version of the Knights of the Round Table. However, some samurai did fight on their own, and these rogue samurai were called *ronin*. They were not nice guys—not nice at all. They didn't help old ladies cross the street. And when they sliced off people's heads, they didn't warn them first. Guess which type we're going to draw today? That's right, the bad kind. The kind who kills and likes it.

This samurai is sturdily built, not lean and long like other more elegant, sophisticated occult characters. He's shorter and fairly low to the ground in order to retain superb balance when executing spinning and twisting moves. Notice that the construction of this figure is slightly stockier than the other male figures we've been working with.

SHORT NECK

THICK, STOCKY TORSO

NORMAL LEGS— NOT SUPER- ELONGATED

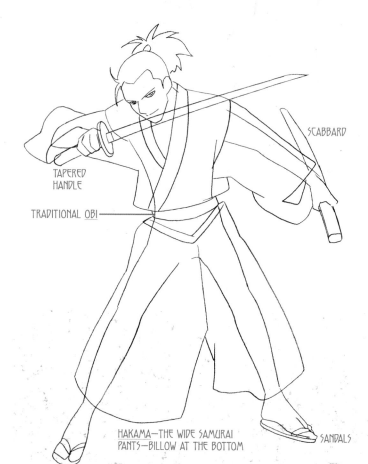

SCABBARD

TAPERED HANDLE

TRADITIONAL OBI

HAKAMA—THE WIDE SAMURAI PANTS—BILLOW AT THE BOTTOM

SANDALS

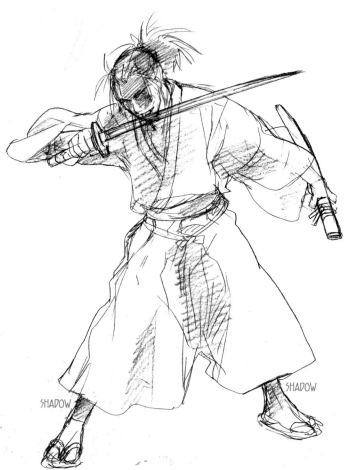

SHADOW

SHADOW

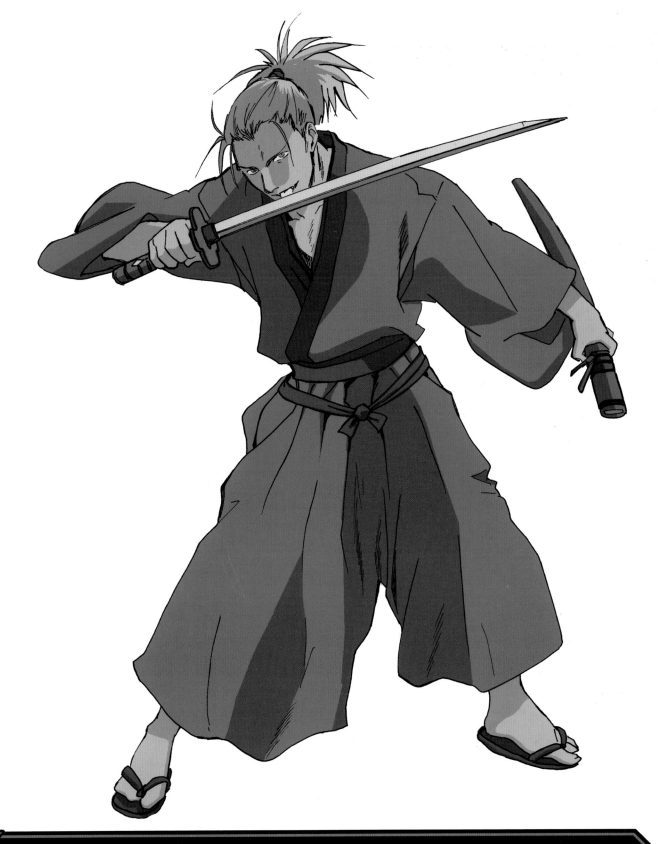

Small Gestures Add Character

Don't overlook the small details when designing your characters. For instance, the warped samurai might lick his blade before he gets ready to fight. It's a small ritual, but it tells us a lot. It says that, for him, killing is sweet; it almost has a taste.

You can create any type of small gesture or ritual you want. One of the best was the lollipop-eating habit of the Kojak character, created by Telly Savalas. Who had ever seen a hard-boiled detective who always had to have his lollipop while investigating a case? It was a unique ritual that was just one small ingredient—but it won over legions of fans. And you, too, can invent a ritual like that to make your characters richer.

Evil Cuties

We humans have puppies for companionship. Guys and gals from the Dark World have little, squeezable, freaky companions. Yes, they're a bit...weird looking. But you didn't expect a dragon-woman to carry a Chihuahua in her purse, did you?

These puffy little critters aren't so evil, really. And they're easy to draw. They add humorous relief to an otherwise melodramatic genre. They can fly, float, and spring into and out of this dimension in a heartbeat.

FUZZBALL BAD KITTY

Note that hands and fingers are unnecessary on extra-round characters.

COWBOY POTATO INVADER

Sometimes, you can go all-out silly, just for laughs, even in a spooky genre.

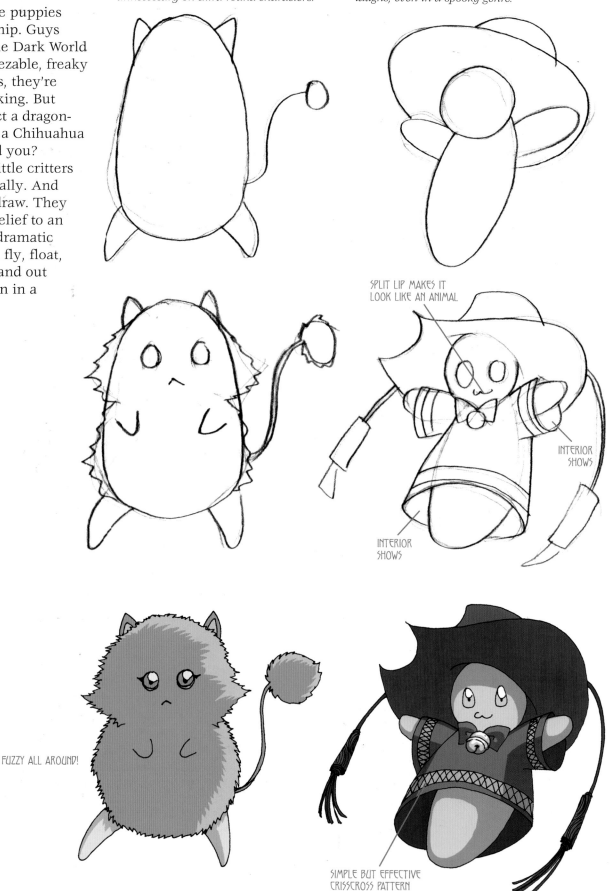

SPLIT LIP MAKES IT LOOK LIKE AN ANIMAL

INTERIOR SHOWS

INTERIOR SHOWS

FUZZY ALL AROUND!

SIMPLE BUT EFFECTIVE CRISSCROSS PATTERN

HALLOWEEN RABBIT

FLYING PLAY PET

This little companion is drawn in a style more in keeping with that of her occult owners—and less as a comedic sidekick.

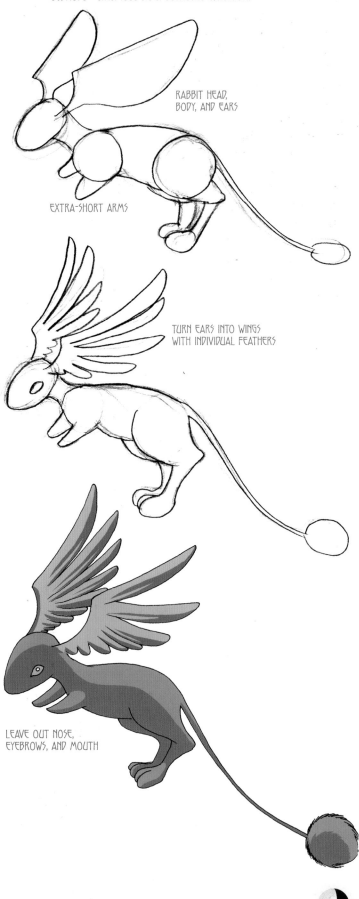

RABBIT HEAD, BODY, AND EARS

EXTRA-SHORT ARMS

TURN EARS INTO WINGS WITH INDIVIDUAL FEATHERS

GOOFY FACE

JACK-O'-LANTERN BODY

LEAVE OUT NOSE, EYEBROWS, AND MOUTH

The Stranger

Into every good story comes a stranger. Who is he? What does he want? How much does he know? Is he good or bad? Is he working for the underworld or for himself? We are left to guess, but one thing's for sure: His entrance upsets the equation. His purpose is to throw the story into high gear, to add the element of surprise. He's the random card, the joker. Now the deck is shuffled. Let the game begin.

This guy is dressed a little out of sync with the genre, which makes his appearance all the more notable. Into the darkness comes this stylishly dressed man. As with everything else about him and his restrained personality, he is concealed by his clothes. He is a tall, quiet type but not easily intimidated. He will stare down danger without taking a step back. Take a swing at him and you'll be looking up at him from the ground with a bloody lip before you know what hit you.

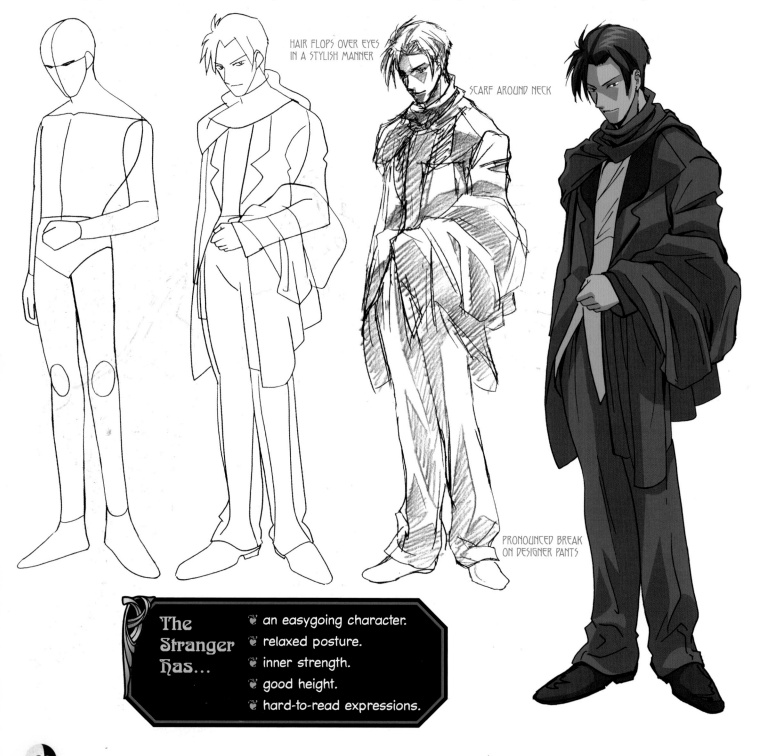

HAIR FLOPS OVER EYES IN A STYLISH MANNER

SCARF AROUND NECK

PRONOUNCED BREAK ON DESIGNER PANTS

The Stranger Has...
- an easygoing character.
- relaxed posture.
- inner strength.
- good height.
- hard-to-read expressions.

Sorceress

When the Going Gets Tough . . .

The remaining characters in this chapter are a bit more challenging to draw, but they provide lots of inspiration. The last few steps of each are a bit more complex, as the costumes and finishing touches get more detailed and intricate. But you're not the same artist you were when you started. Try pushing your creative boundaries a little. There's no need to get it perfect on your first attempt. If you get just one or two aspects of the drawing done well, feel good about your efforts. As you continue on the path, you'll develop more strengths. Don't get discouraged.

I personally find wizard characters very alluring and mysterious. You can't tell whether they're going to cast a good spell on you or curse you with some terrible affliction—perhaps even change you into an animal. The hooded robe is a classic costume for a sorcerer or sorceress. The veiled look underscores the enigmatic aura of the character. The long staff is also a classic. Stay away from wands, which are for fairy godmothers. The slit in the long dress shows us that we're in the occult genre, where dark and mysterious characters are still attractively drawn.

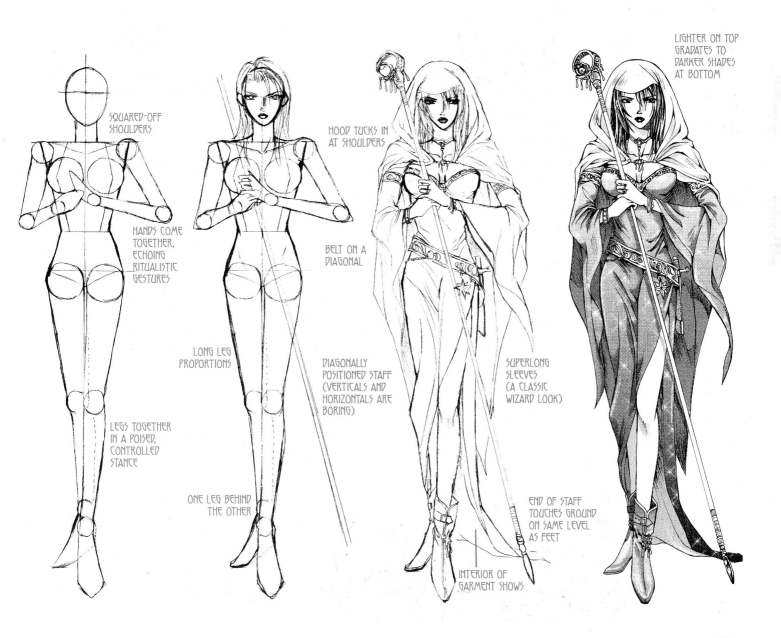

SQUARED-OFF SHOULDERS

HANDS COME TOGETHER, ECHOING RITUALISTIC GESTURES

LEGS TOGETHER IN A POISED, CONTROLLED STANCE

LONG LEG PROPORTIONS

ONE LEG BEHIND THE OTHER

HOOD TUCKS IN AT SHOULDERS

BELT ON A DIAGONAL

DIAGONALLY POSITIONED STAFF (VERTICALS AND HORIZONTALS ARE BORING)

INTERIOR OF GARMENT SHOWS

END OF STAFF TOUCHES GROUND ON SAME LEVEL AS FEET

SUPERLONG SLEEVES (A CLASSIC WIZARD LOOK)

LIGHTER ON TOP GRADATES TO DARKER SHADES AT BOTTOM

Bewitched Beast: Wolf-Demon

One of the more interesting characters in manga is the demon beast. Once a human but now under the spell of a wicked magician, this person-turned-beast roams the land, forever doomed to inhabit the world in animal form. His terrible condition makes him angry, furious, vicious. He has lost everything: his true love, his family, his humanity. But every so often, a flicker of light enters his dark heart when he sees someone in trouble, and he comes to the rescue.

You might ask yourself, If he's such an interesting character, why don't we see more of him? This is something I learned as a screenwriter in Hollywood, and it applies to all good storytelling, including both manga and American-style comics: When you have something special that's very effective, resist the impulse to use it all the time.

To illustrate: Do you remember the classic Christmas movie *It's a Wonderful Life* starring Jimmy Stewart? What character springs to mind first? For me—and for most people, I suspect—it's Clarence the angel. But Clarence only appears at the tail end of the rather long film. Yet he was so memorable, we tend to think that the film was all about his relationship with George, Jimmy Stewart's character. It wasn't. However, if the screenwriter had written Clarence into the picture in the first act and called the movie *Here's Clarence!*, I can guarantee you we would not be watching reruns of the film every Christmas Eve on television some fifty years later.

LONG LEGS ADD HEIGHT

Here's a little-known fact about wolves that can help you draw them so that they look different than dogs: Wolves have longer legs than dogs. This gives them that gangly, creepy look that works so well in the horror genre. Note that the long, thin tail is a fantasy addition not seen on true wolves.

Ears placed a little more forward on the head than normal give him an alert look. Long, sharp claws on the paws are, as with any obvious mutation, a good way to enhance the creature. The objective is to move the animal away from its true look and into the fantasy realm of the occult.

The collar is not utilitarian but seems to have a symbolic design. The jewel in the middle of the forehead conveys a magical power or symbolic meaning (your readers don't even have to know what it means—all they have to know is that this ain't no regular animal). The prisoner-type metal cuff on the front left ankle is symbolic of his cursed condition, and the braided tail takes another character-design step into the fantasy realm.

ONLY YOU CAN HEAR ME, NOW, COME WITH ME, AND I WILL SAVE YOU.

This type of character can often choose to communicate with one person through his thoughts—no one else can hear him.

She looks like any other woman, except that she's from the Land of Darkness. It's important to keep the following in mind: It works better to make a demon girl pretty and sweet looking, rather than ugly and repulsive. If she's ugly and repulsive, the reader can simply dismiss her. But if she's attractive and sweet, the reader will have ambivalent feelings about her and will stay engaged in the story.

Still, there are those pesky little reminders of who she really is, such as the devil ears and the tail. You won't find items like these on the girl-next-door character.

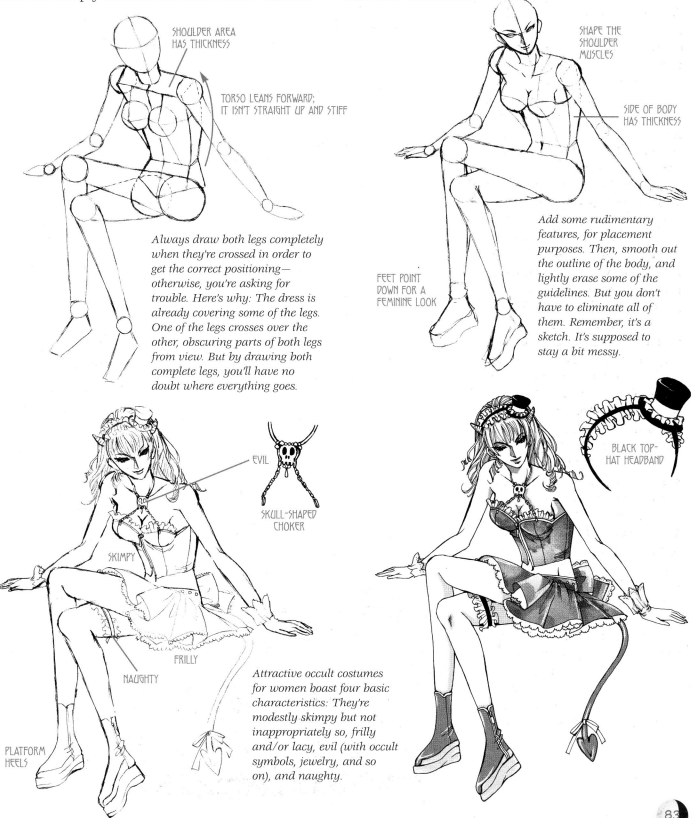

SHOULDER AREA HAS THICKNESS

TORSO LEANS FORWARD; IT ISN'T STRAIGHT UP AND STIFF

Always draw both legs completely when they're crossed in order to get the correct positioning—otherwise, you're asking for trouble. Here's why: The dress is already covering some of the legs. One of the legs crosses over the other, obscuring parts of both legs from view. But by drawing both complete legs, you'll have no doubt where everything goes.

SHAPE THE SHOULDER MUSCLES

SIDE OF BODY HAS THICKNESS

FEET POINT DOWN FOR A FEMININE LOOK

Add some rudimentary features, for placement purposes. Then, smooth out the outline of the body, and lightly erase some of the guidelines. But you don't have to eliminate all of them. Remember, it's a sketch. It's supposed to stay a bit messy.

EVIL

SKULL-SHAPED CHOKER

SKIMPY

NAUGHTY

FRILLY

PLATFORM HEELS

Attractive occult costumes for women boast four basic characteristics: They're modestly skimpy but not inappropriately so, frilly and/or lacy, evil (with occult symbols, jewelry, and so on), and naughty.

BLACK TOP-HAT HEADBAND

Tarot Card Reader

Your future is revealed in the cards. She deals them, one by one. A card is turned over. It reveals prosperity and health. The next card, wisdom and love. Your card is next. What shall it be? Life or death? Your world is in her hands. Dare you ask? Dare you look?

This character is more than a mere fortune-teller. She's a seer. A "looker" into the future. Her dress, her companions, her surroundings, and even the props around her should all shroud her in mystery and magic. Her key is a very special deck of cards that only she can read. Were you to take the deck from her hands and look at it, all you would see would be blank cards, for your eyes are not ready to grasp all that your future holds. It would be too much for you.

Hint:
Spooky Props
& Wardrobe

Be creative with the things furnishing both the scene and the character. They should all add atmosphere: a raven, a standing candelabra, a crystal ball, a black cat, a drapery-covered chair, scarves, layers, bracelets, sandals, and curly flowing hair. It's a classic gypsy look: wild, attractive, bohemian, uncanny.

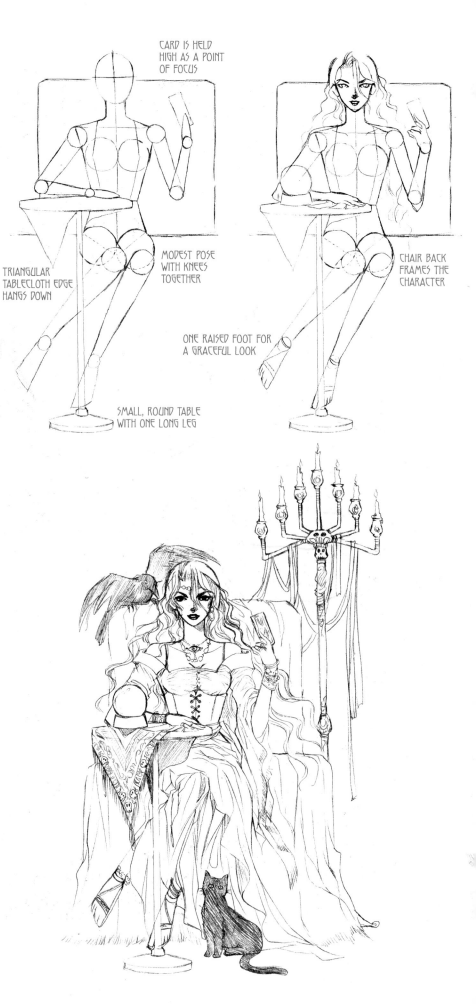

CARD IS HELD HIGH AS A POINT OF FOCUS

MODEST POSE WITH KNEES TOGETHER

TRIANGULAR TABLECLOTH EDGE HANGS DOWN

ONE RAISED FOOT FOR A GRACEFUL LOOK

CHAIR BACK FRAMES THE CHARACTER

SMALL, ROUND TABLE WITH ONE LONG LEG

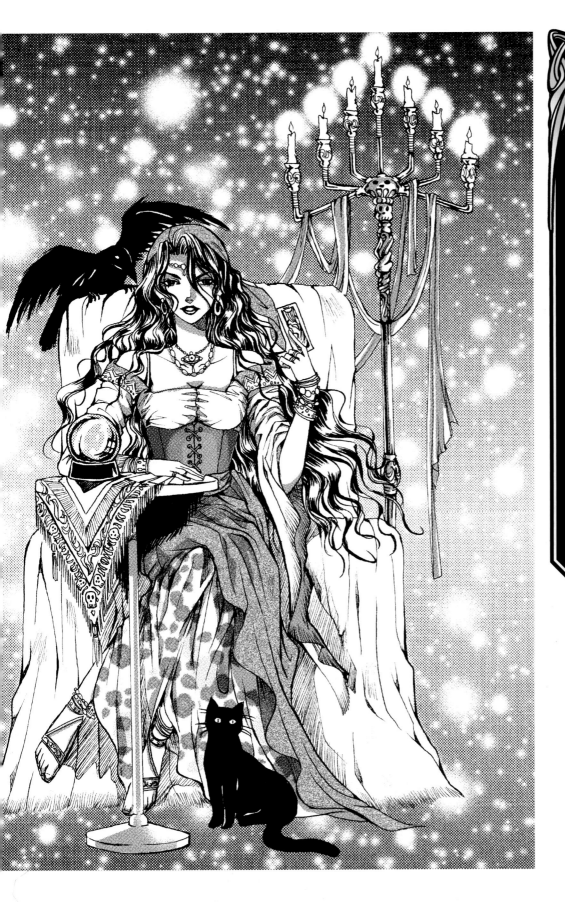

Rather than always using a literal, representational background, you can—depending on the character—get away with using something a little more abstract. A mystical tarot card reader is a good character for this kind of treatment. Here she's floating in space and time. It is a limitless background, almost as if she has entered the mind of the observer. The alternative is to put her in a small storefront from which she does her readings. Sometimes, showing the scene from the point of view of the character who is experiencing it (i.e., the one getting his or her future told) is more effective than showing the viewpoint of the neutral observer (i.e., the reader).

The Experiment

Creating evil in a tank is no small feat. It takes a huge amount of liquid, a group of scientists, and many tubes and monitors. This is a popular conceit in manga, as well as in American comics and horror movies. Here, the female creature, in a state of suspended animation, floats in a tank while the scientists take copious notes, regulating her life-support systems.

To show that she's in water, have the hair float toward the surface. Be sure to draw it in a wavy manner. Note that the figure in the tank is positioned higher within the picture than the scientists. This sets her apart, making her different— an outcast among the group.

Bunch her up, as if she were going to do a cannonball into a swimming pool. The chin is tucked down to the knees.

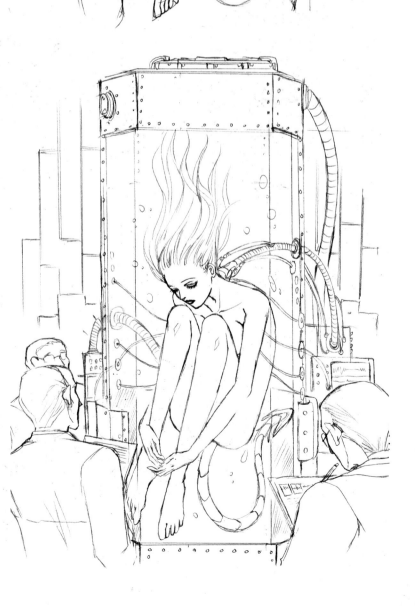

An oval-shaped or round tank doesn't look reinforced or scientific. It looks like an aquarium. The octagonal shape is more antiseptic and allows you to draw vertical metal reinforcements with rivets. Draw lots of tubes going from the subject of the experiment to the monitors outside of the tank.

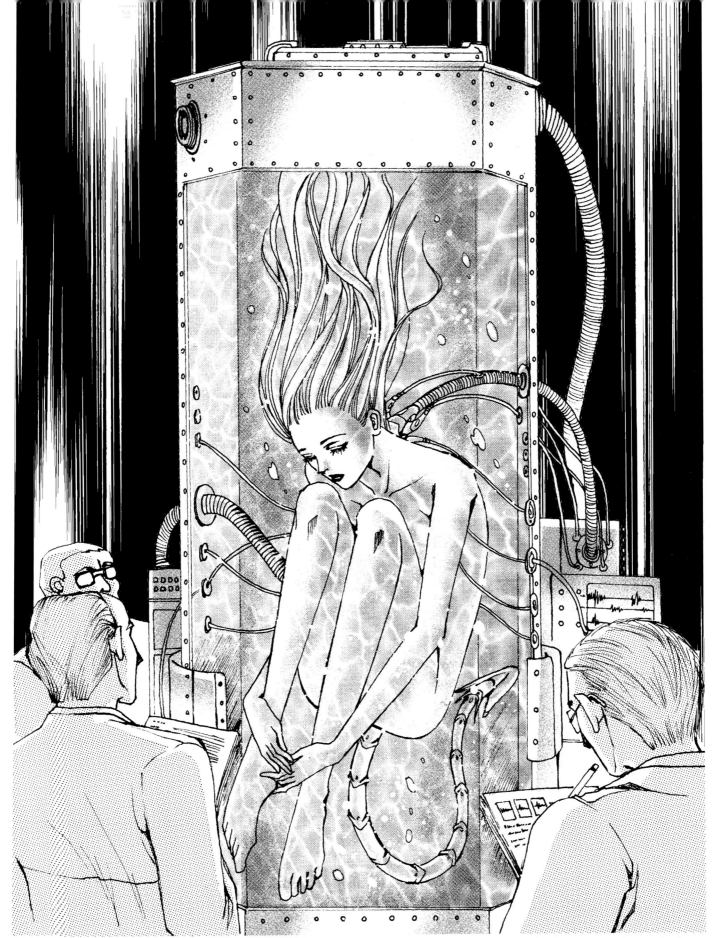

To highlight her solitary condition, blacken the background. The white, vertical stripes are purely a design element that adds a sense of energy to the scene, which is otherwise compelling but static.

Dragon Lady: Drawing a Possessed Character

She gets her powers and commands from the dragon. Once, she was a princess, about to marry on the far side of a golden lake when she was captured in the talons of the flying beast and brought to its cave. Now, under the dragon's spell, she steals away each night and returns to her castle to retrieve precious gems that make the dragon's powers grow stronger still.

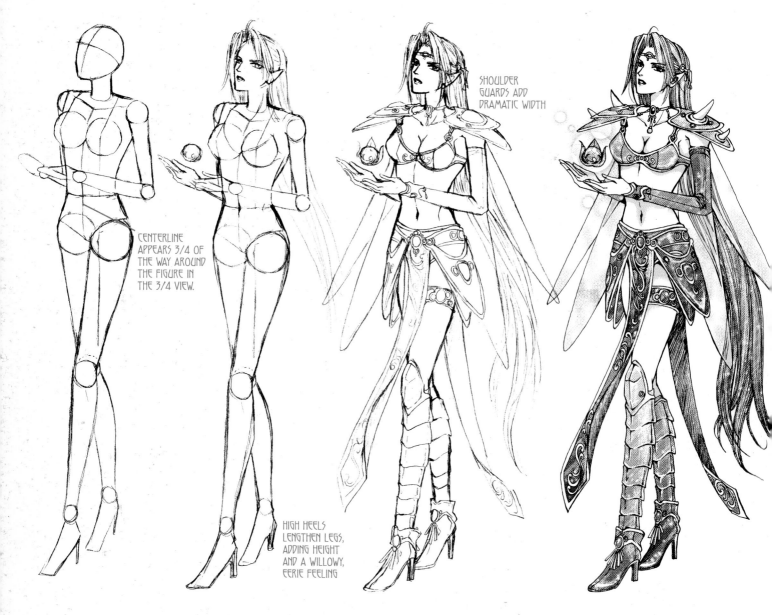

CENTERLINE APPEARS 3/4 OF THE WAY AROUND THE FIGURE IN THE 3/4 VIEW.

HIGH HEELS LENGTHEN LEGS, ADDING HEIGHT AND A WILLOWY, EERIE FEELING

SHOULDER GUARDS ADD DRAMATIC WIDTH

For possessed characters, draw stiff posture, straight up and down, with the chin held up. Tilt the head back slightly, and show the hands in a servile position, as if holding a tray. The eyes are open and looking forward—but are unfocused.

The power of the amulet causes it to float above her hands.

Use visual cues to tell the reader about the character. (This is how an artist tells a story.) Here, as this character becomes less princesslike and more dragonlike, draw her to look more like a dragon, so the reader can see what's happening to her. Since dragons have wings, give her wings. Design armor elements that echo the scales of the dragon's skin. Put horns, like dragon horns, on her shoulder guards. This develops a consistent theme.

Especially in the occult style, gray and black can be as effective as color, because of the tone of the subject matter. Still, great color is dazzling, which is why all covers of manga graphic novels are in color. (See pages 141–143 for more on the colors of manga occult and horror.)

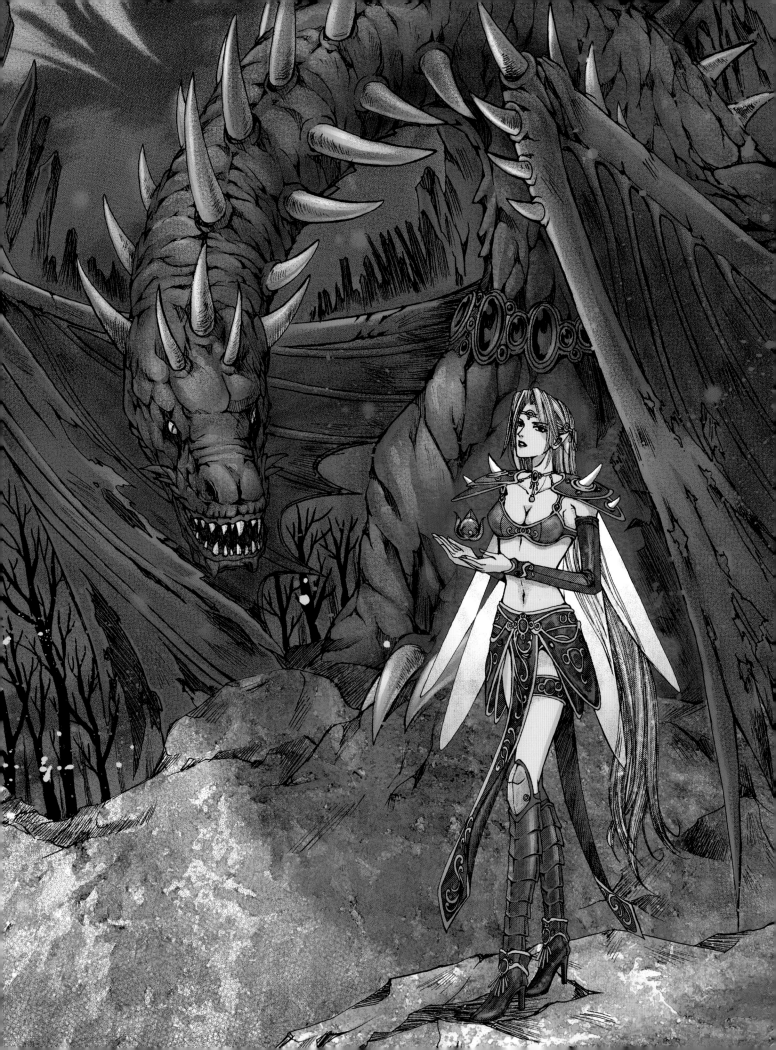

COSTUME DESIGN

Of all the styles of comics, manga occult-and-horror has the most interesting pictorial evolution, which begins in late-nineteenth-century London. Famous stories (such as *Dr. Jekyll and Mr. Hyde*) and historical serial killers (such as *Jack the Ripper*) were all remembered with a scandalous twist of glamour, whether deserved or undeserved, and they influenced creative minds.

As the aristocracy dabbled with the forces of evil, the Pandora's box opened. There was an undeniable romantic quality to aristocratically attired, wicked characters, and the genre took hold. It's not so hard to trace the lineage of costume design and see how these origins morphed into today's popular manga occult-and-horror style. A lot of the past is still with us today. And evil never goes out of fashion. It just gets a facelift. Let's take a look.

Ah, the Victorian Age. Fair ladies and dashing young men. No one wore jogging pants and Nikes. You wore so many layers that a servant had to dress you. Showing a bit of the neckline was about as daring as a girl could get. The men were buttoned from top to bottom—even some of the shoes had buttons on them!

Traditional Men's Garments and Accessories

As you look at the examples in this chapter, note that it's often the more traditional details and flourishes that give the outfits their style. Men's costumes often make use of top hats, capes, canes, high collars, wide lapels, folded handkerchiefs, and a single rose. Below are a few of the more popular garment details and accessories for men's outfits.

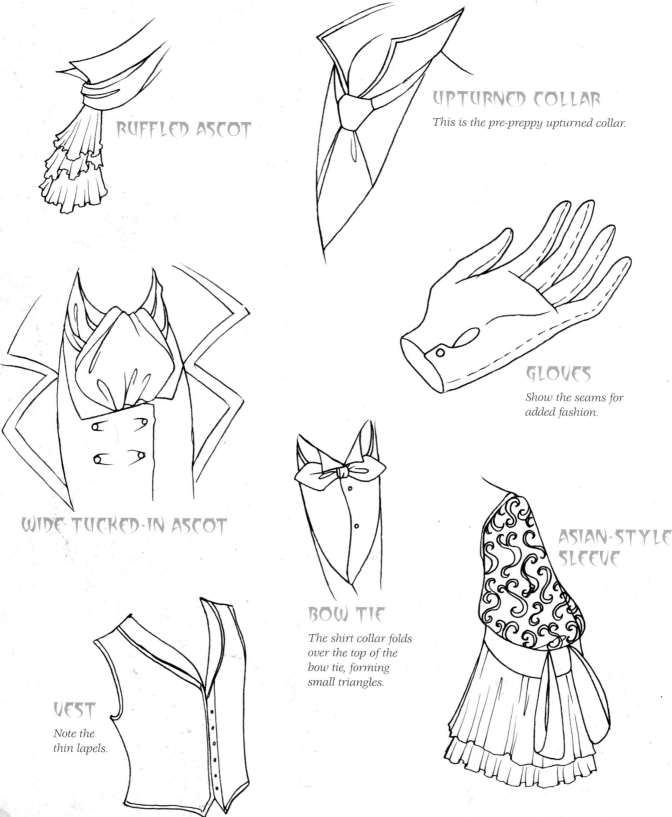

RUFFLED ASCOT

UPTURNED COLLAR

This is the pre-preppy upturned collar.

GLOVES

Show the seams for added fashion.

WIDE TUCKED-IN ASCOT

ASIAN-STYLE SLEEVE

BOW TIE

The shirt collar folds over the top of the bow tie, forming small triangles.

VEST

Note the thin lapels.

Men in the Drawing Room

Dinner parties were a big affair in the Victorian Age. After dinner, the men retired to the drawing room to smoke and discuss current affairs. In manga occult, in any room full of barons, one will prove to be a creature of the night: one of the living dead, a being condemned to prey on mortals for his very existence. And he'll look good doing it.

Traditional Women's Garments and Accessories

Corsets, overworked hairstyles, layer upon layer of clothing, powder-perfect makeup . . . and you thought your sister took a long time to get ready for a date! Like the men's outfits, women's fashions benefit greatly from attention to traditional details: flounces galore, drapery-like folds in garments, laces up the back to tighten the waist, long trains, ornamental dangling earrings, long necklaces, and bracelets. Here are a few more.

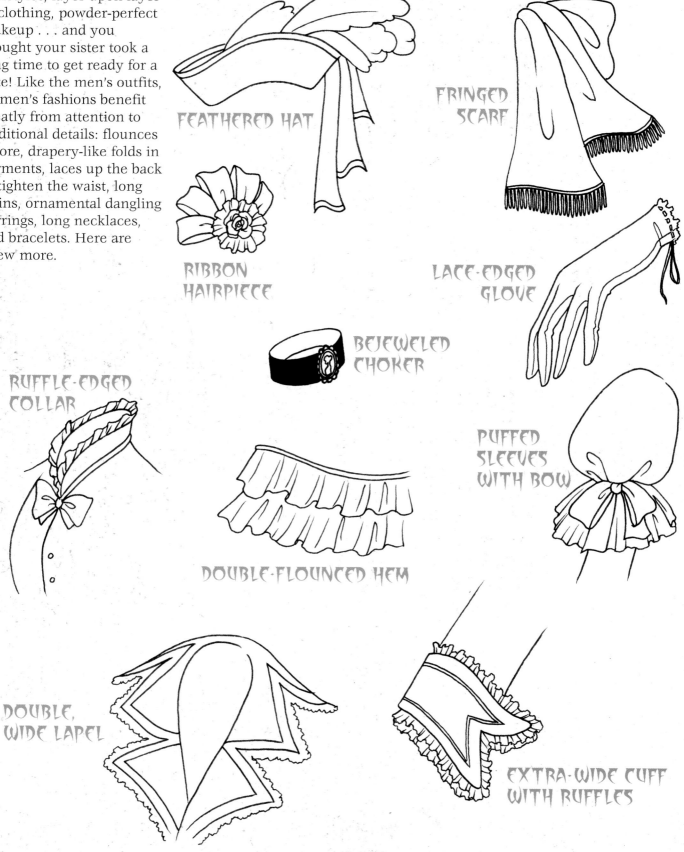

FEATHERED HAT

FRINGED SCARF

RIBBON HAIRPIECE

LACE-EDGED GLOVE

BEJEWELED CHOKER

RUFFLE-EDGED COLLAR

DOUBLE-FLOUNCED HEM

PUFFED SLEEVES WITH BOW

DOUBLE, WIDE LAPEL

EXTRA-WIDE CUFF WITH RUFFLES

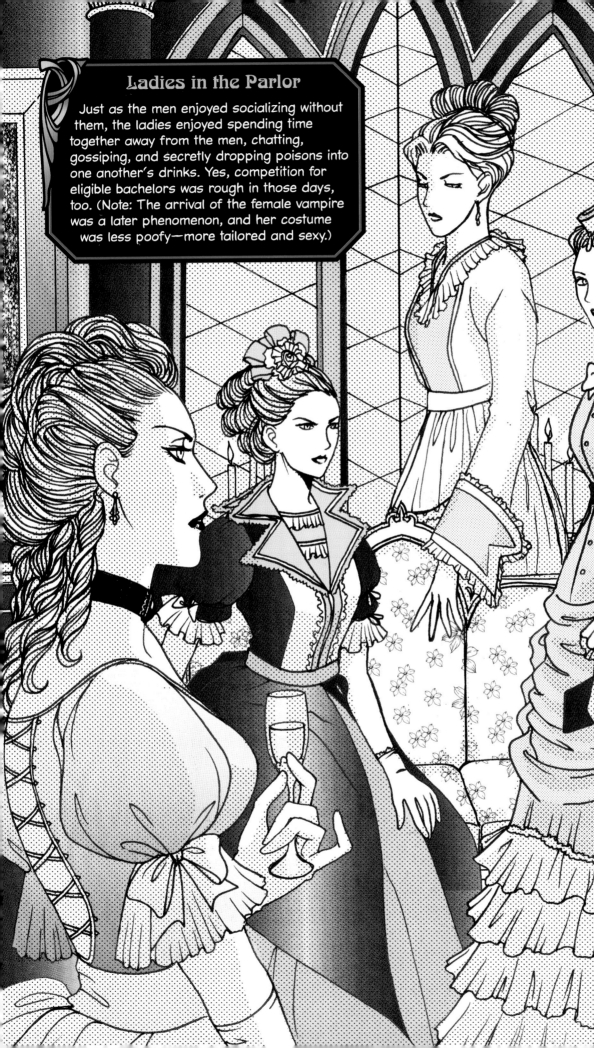

Ladies in the Parlor

Just as the men enjoyed socializing without them, the ladies enjoyed spending time together away from the men, chatting, gossiping, and secretly dropping poisons into one another's drinks. Yes, competition for eligible bachelors was rough in those days, too. (Note: The arrival of the female vampire was a later phenomenon, and her costume was less poofy—more tailored and sexy.)

Occult Gothic Costume

Dark, aristocratic characters from the Victorian Age evolved directly into the popular gothic characters that make up a large segment of today's sophisticated, urbane occult-and-horror manga. These characters maintain the elegance, poise, and style of their mysterious forebears, but they are decidedly modern. Their clothes are still ornate, with traditional touches, but are also macabre. The characters are brooding, and lean, which adds up to a more dangerous look. Instead of simply being mysterious, for example, our new vampire is more introverted, trying to tamp down a cauldron of turbulent emotions. He is a troubled, violent person—a powder keg, boiling quietly just below the surface.

OCCULT GOTHIC MAN

The long jacket borrows from the trench coat look of modern noir, nihilistic characters.

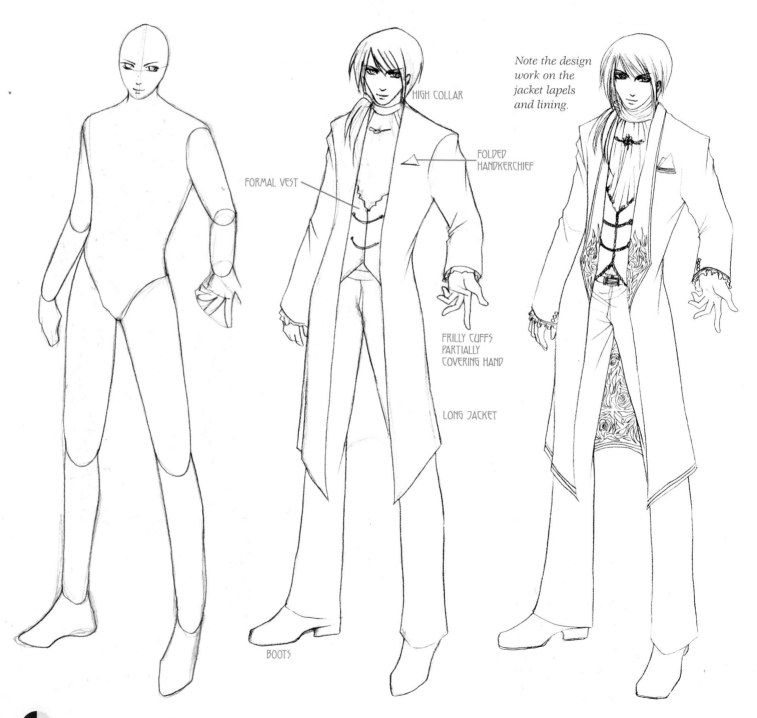

HIGH COLLAR

FOLDED HANDKERCHIEF

FORMAL VEST

FRILLY CUFFS PARTIALLY COVERING HAND

LONG JACKET

BOOTS

Note the design work on the jacket lapels and lining.

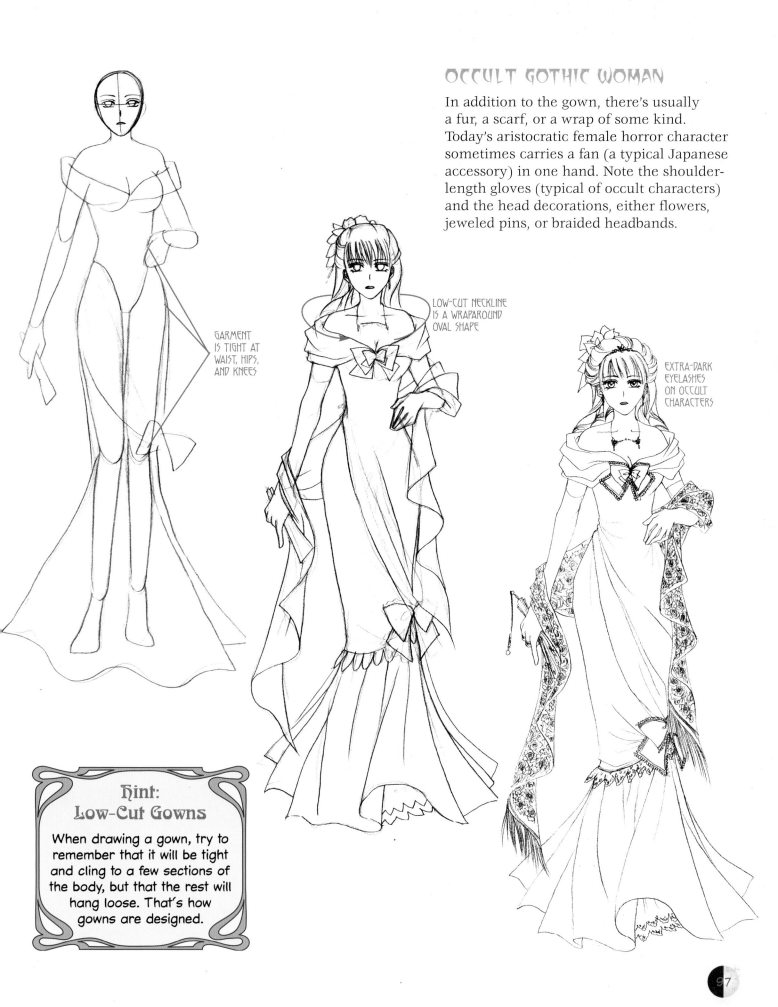

OCCULT GOTHIC WOMAN

In addition to the gown, there's usually a fur, a scarf, or a wrap of some kind. Today's aristocratic female horror character sometimes carries a fan (a typical Japanese accessory) in one hand. Note the shoulder-length gloves (typical of occult characters) and the head decorations, either flowers, jeweled pins, or braided headbands.

GARMENT IS TIGHT AT WAIST, HIPS, AND KNEES

LOW-CUT NECKLINE IS A WRAPAROUND OVAL SHAPE

EXTRA-DARK EYELASHES ON OCCULT CHARACTERS

Hint: Low-Cut Gowns

When drawing a gown, try to remember that it will be tight and cling to a few sections of the body, but that the rest will hang loose. That's how gowns are designed.

Layering

One of the prominent features of gothic-style costumes is the *layering*. Here, we see a jacket under a jacket. It's a cool look that lends itself to interesting design possibilities—in this case, that square cutout shape just above the waist.

The long tails of the flying creatures help convey the feeling of motion and elongate the line of the direction in which the creatures are moving.

The wide trench coat is a great look. Keep it tight around the waist so that it can billow at the ankles, creating a nice contrast in shape.

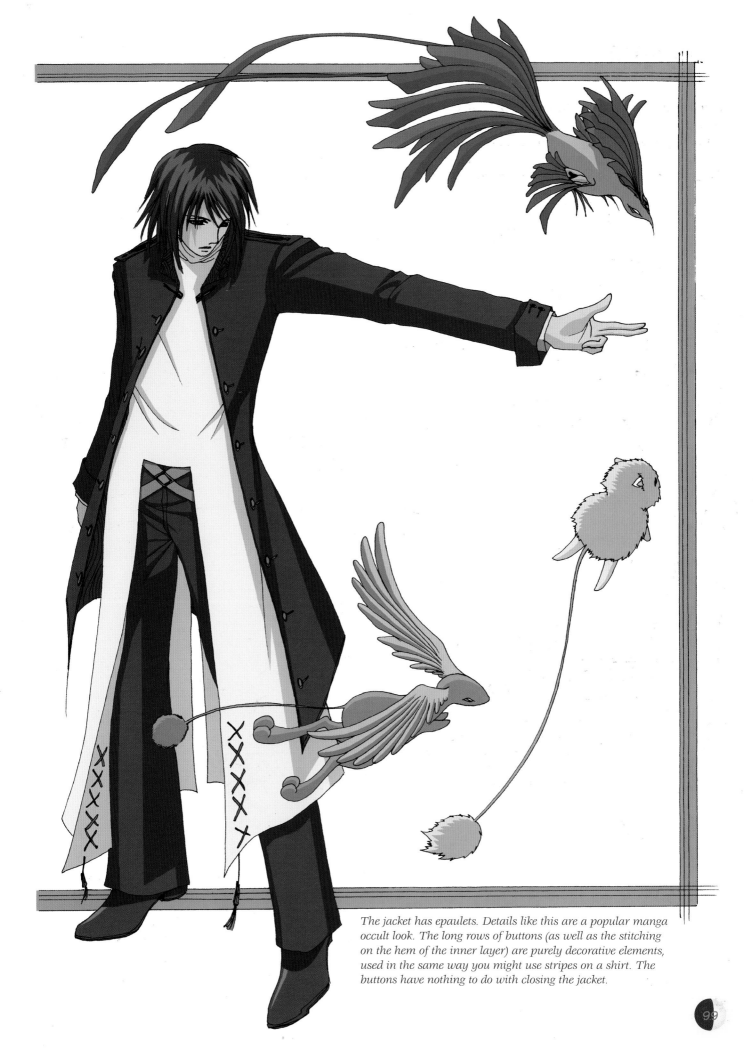

The jacket has epaulets. Details like this are a popular manga occult look. The long rows of buttons (as well as the stitching on the hem of the inner layer) are purely decorative elements, used in the same way you might use stripes on a shirt. The buttons have nothing to do with closing the jacket.

The Long Train

A dress with a train—the part of the dress that drags behind the figure—results in a severely formal look. It's great for characters living in castles or attending balls.

FORESHORTEN THE FOREARM

BENT KNEE SHOWS OUTLINE OF LEG UNDER GARMENT

DRESS FALLS AWAY FROM LEG

PRETTY LINING FABRIC ADDS A MYSTERIOUS FLAVOR

TRAIN OF DRESS DRAGS BEHIND

Note that the train hem is not just one smooth curve all the way around. It has folds and ripples in it like any fabric.

Using Embellishment

Using a combination of embellishments helps you create a fuller character that has more visual interest. For example, look at the clothing details on this semi-gothic man: Nehru collar, epaulets, braided cord, layered jackets, decorative stitching, elaborate cuffs, and split and embroidered pant cuffs. Regardless of genre, use this as a guide for thinking about costume design and attention to detail.

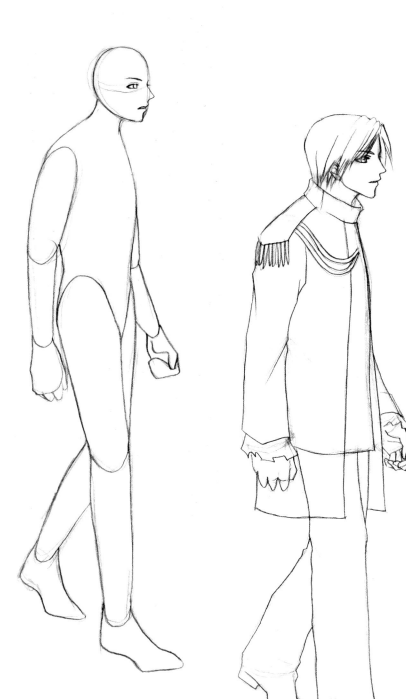

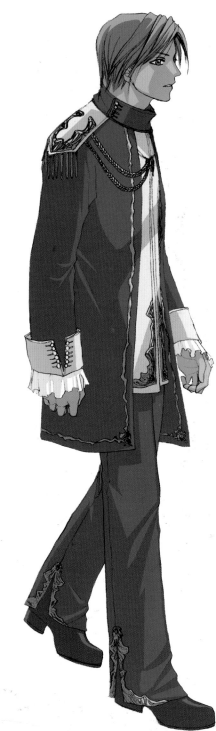

Semi-Gothic Characters

Semi-gothic characters are young, romantic types also popular in manga occult and horror. These are the good characters who live among the evil ones but are unharmed by them. Perhaps they were taken as infants and raised by vampires as their own. But their true innocent natures could never be changed.

Popular Occult Costume Styles

Some occult styles are purely one genre. Others blend manga genres to offer a fresh take on established themes, and the costumes reflect this. Genres, such as horror or shoujo or chibi, used to be firmly fixed in place. But artists found these boundaries too constrictive and arbitrary, so they started breaking them. And readers responded. As a result, there's more freedom now than ever. In your own art, try bringing a new angle to a genre. Readers are open to it. They're always eager to see the next new thing. Are your ideas too far out? Maybe. Or maybe your ideas are just what everyone's been waiting for. Again, regardless of which genre or combination of genres you explore, the costume reflects it and helps convey it to the reader. Take a look.

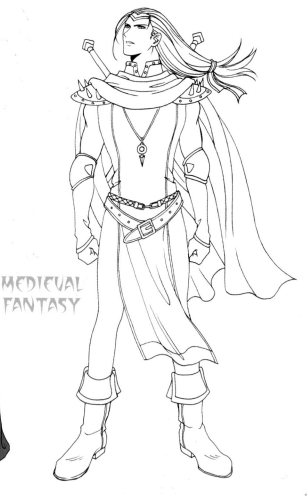

MEDIEVAL FANTASY

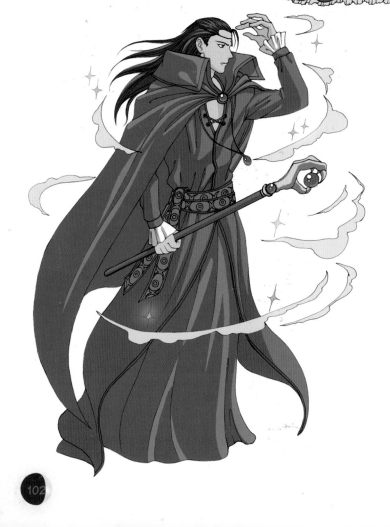

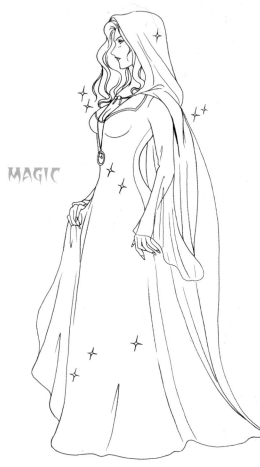

MAGIC

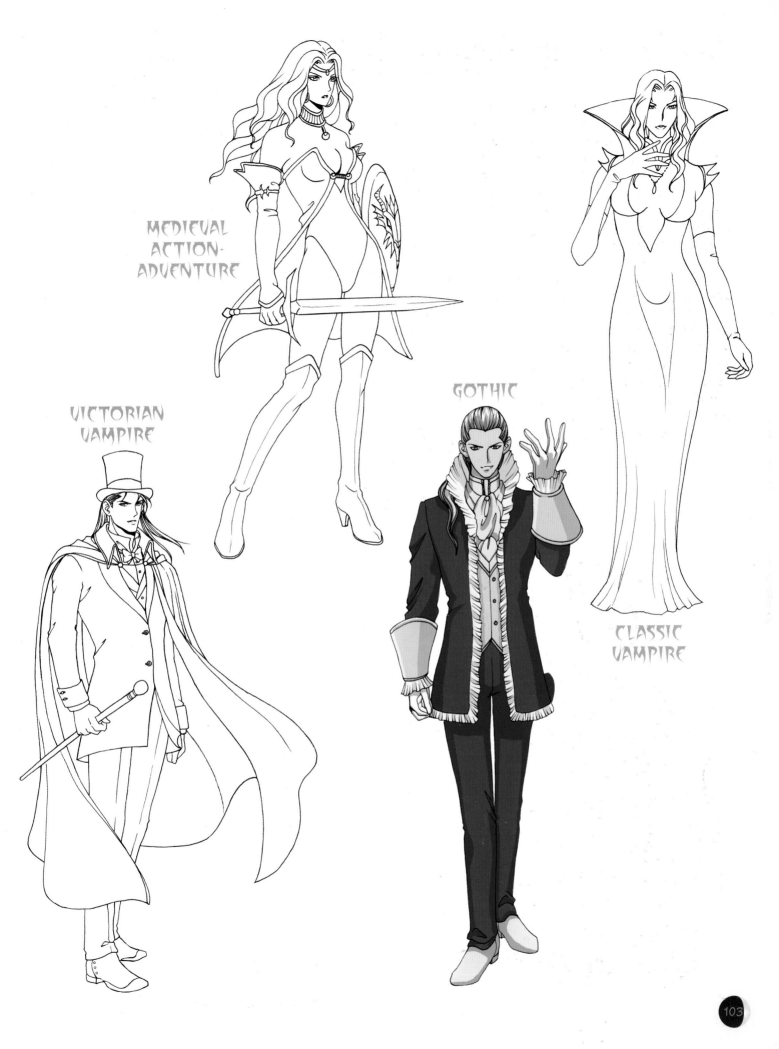

MEDIEVAL
ACTION-
ADVENTURE

VICTORIAN
VAMPIRE

GOTHIC

CLASSIC
VAMPIRE

Combining Horror with Fantasy

The most common genre to be combined with manga occult and horror is fantasy, especially with characters that hunt and fight the beasts of the underworld. The horror genre makes use of many mythological animals, demons, beasts, and animal-human hybrids, and somebody's got to hunt them down if the humans are to have any chance of survival. These hunters are borrowed from the fantasy genre, and their costumes are given a medieval twist.

ELFIN "BOY" HUNTER

Elves are, by definition, from the fantasy world. Their elfin ears are clear fantasy elements. The cape is seen in both the fantasy and occult genres. The medieval costume and boots straddle the fence between occult and fantasy. Remember, not too long before the 1700s and 1800s in Europe was the medieval period. In the late medieval period, armor and jousting became used more for pageantry than for actual combat, as the days of knights were coming to a close. The costumes, however, continued to influence style. In manga, this medieval style branched off in two directions: occult and fantasy. That is how they are intertwined and have remained closely related.

Like most elves, this character appears young for his years. Small in stature but eager and spry, the elfin "boy" appears to be about 12 to 14 years old, when, in fact, he's north of about 140. Sounds great, but elfin kids don't leave home until they're 60.

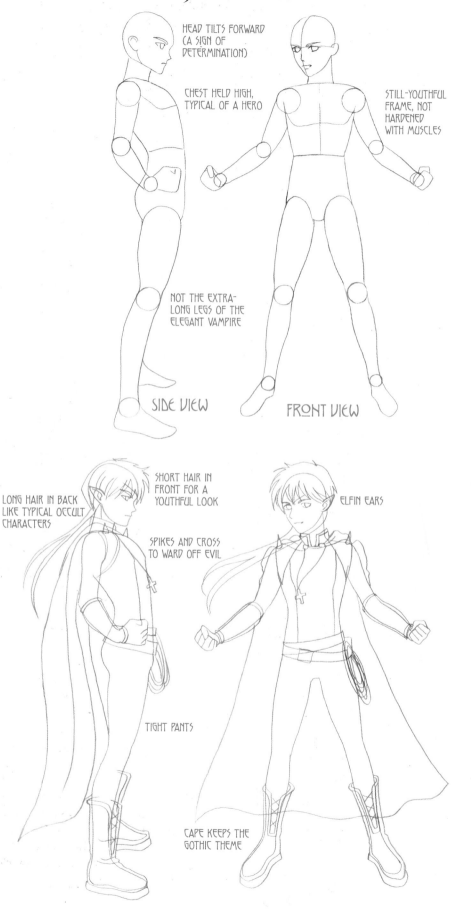

HEAD TILTS FORWARD (A SIGN OF DETERMINATION)

CHEST HELD HIGH, TYPICAL OF A HERO

STILL-YOUTHFUL FRAME, NOT HARDENED WITH MUSCLES

NOT THE EXTRA-LONG LEGS OF THE ELEGANT VAMPIRE

SIDE VIEW

FRONT VIEW

LONG HAIR IN BACK LIKE TYPICAL OCCULT CHARACTERS

SHORT HAIR IN FRONT FOR A YOUTHFUL LOOK

SPIKES AND CROSS TO WARD OFF EVIL

ELFIN EARS

TIGHT PANTS

CAPE KEEPS THE GOTHIC THEME

Body Attitude

As with most young, eager manga characters, the expression and body attitude are what make this figure believable. He looks like he's ready to fight, no matter how intimidating or ferocious the demon he's after. Like a cobra ready to strike at any moment, your character must exude a confidence that tells the audience, "Bet on the small guy!"

Hint: Laces

Laces and cross-stitching are oft-repeated motifs in fantasy costumes for men as well as women. These small touches add a fantasy flair to the wardrobe. Above, the cross-stitching appears on the front of the boots; it looks particularly good in combination with the decorative designs on the forearm guards.

TWENTYSOMETHING FANTASY WARRIOR

The difference between the fantasy warrior and the vampire is that the frame of the fantasy fighter will be thicker and more rugged. He's a mysterious leading-man type. When he commits to battle he is an explosive, vicious fighter who gives no quarter. And that's what also makes him exciting. Behind his placid, almost wistful demeanor lies the heart of a warrior.

Various materials are used for the fantasy warrior outfit: metal, leather, cloth, and, sometimes, animal skins. But remember, this character has entered the occult world and the occult genre. Therefore, he must be colored using occult-style colors, not fantasy colors, which are bright. His world is dark and murky—a hellish place where evil often wins. (See pages 141–143 for more on occult color.)

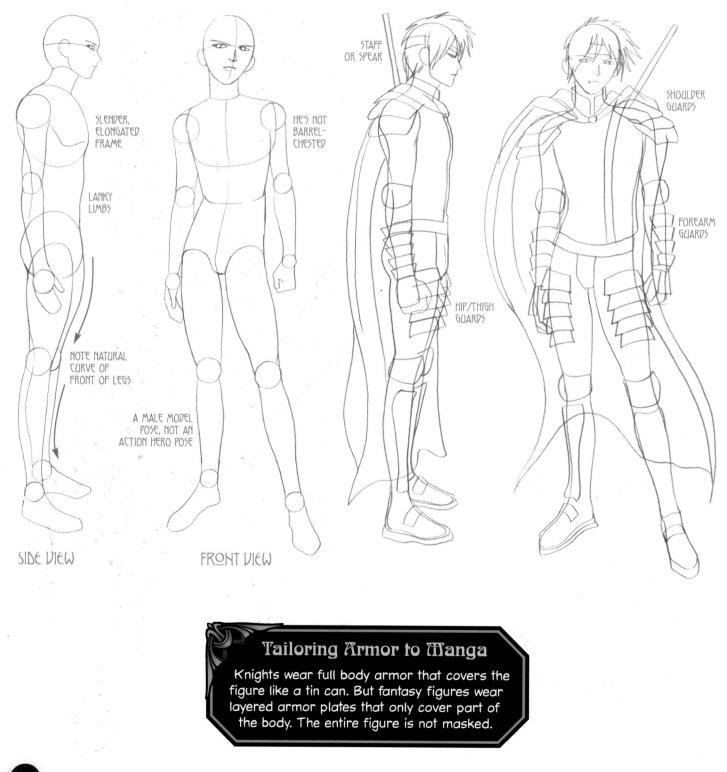

SLENDER, ELONGATED FRAME

LANKY LIMBS

NOTE NATURAL CURVE OF FRONT OF LEGS

SIDE VIEW

HE'S NOT BARREL-CHESTED

A MALE MODEL POSE, NOT AN ACTION HERO POSE

FRONT VIEW

STAFF OR SPEAR

HIP/THIGH GUARDS

SHOULDER GUARDS

FOREARM GUARDS

Tailoring Armor to Manga

Knights wear full body armor that covers the figure like a tin can. But fantasy figures wear layered armor plates that only cover part of the body. The entire figure is not masked.

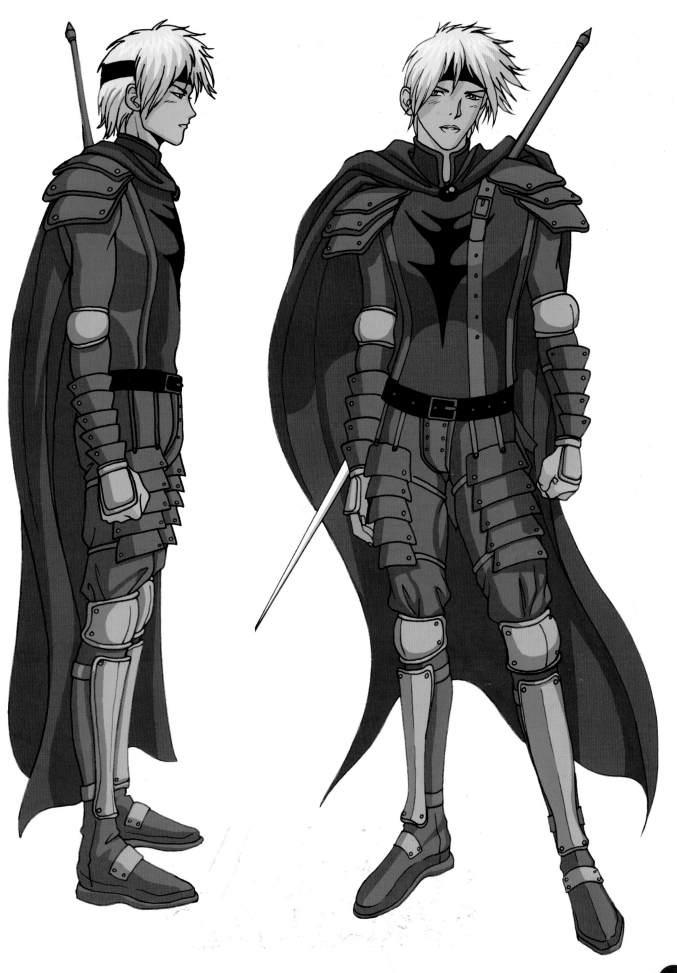

Weapons

Face it, when you find a blood-sucking vampire or a flesh-eating beast, you're not going to be able to talk it into giving itself up. Maybe you can convince your mom of anything, but not these guys. In manga occult, you need to bring something a little more convincing than a good argument. Below, you'll find some excellent options. Oh, and one more thing: Don't fall for the "I had a bad childhood" line. Maybe the vampire can find a good therapist in hell. Give him the stake.

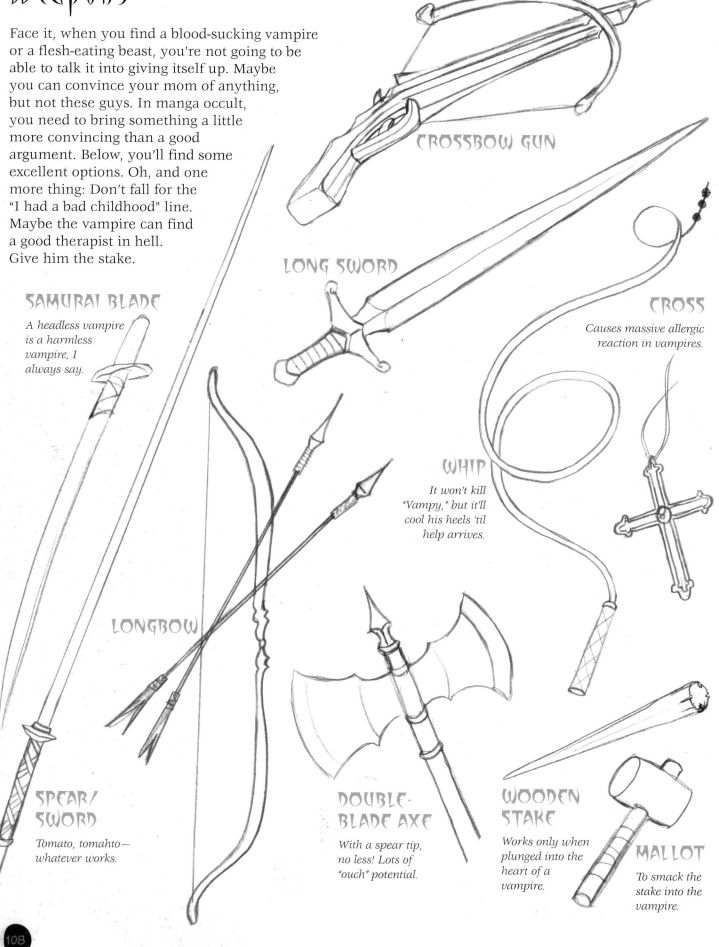

CROSSBOW GUN

LONG SWORD

SAMURAI BLADE

A headless vampire is a harmless vampire, I always say.

CROSS

Causes massive allergic reaction in vampires.

WHIP

It won't kill "Vampy," but it'll cool his heels 'til help arrives.

LONGBOW

SPEAR/ SWORD

Tomato, tomahto— whatever works.

DOUBLE- BLADE AXE

With a spear tip, no less! Lots of "ouch" potential.

WOODEN STAKE

Works only when plunged into the heart of a vampire.

MALLOT

To smack the stake into the vampire.

FANTASY WARRIOR VS. DRAGON

Once engaged in battle, the fantasy warrior will fight to the death—usually the beast's. This is not a genre in which the good prince kills the dragon to win the princess's heart. Sometimes, dragons just piss him off.

Hint: Creative Composition

If you place the giant beast in the foreground and draw it large enough, you can partially cut it off and the reader will focus on the hero, which is what you want.

FANTASTIC TRANSFORMATIONS

One of the aspects of occult and horror that's so unsettling—and downright scary—is that you don't know whom to trust. The person you're talking to—whether it's your best friend, true love, or mentor—could be an illusion hiding a hideous creature that comes out when the moon is full to kill and kill again.

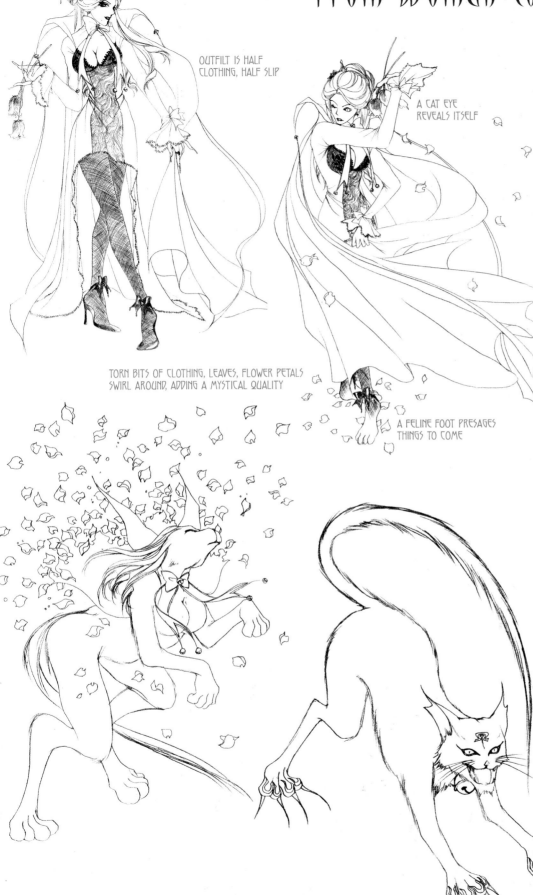

OUTFIT IS HALF CLOTHING, HALF SLIP

A CAT EYE REVEALS ITSELF

TORN BITS OF CLOTHING, LEAVES, FLOWER PETALS SWIRL AROUND, ADDING A MYSTICAL QUALITY

A FELINE FOOT PRESAGES THINGS TO COME

Whatever the starting character and end result, the morphing of manga occult characters could take place in the blink of an eye; in one panel the character could be normal and in the next a demon. But that would be shortchanging the audience. Here's the thing I want to get across: As a manga artist, you *want* your audience to be uncomfortable. Think about it. Would you design a haunted-house ride so that no one got scared? What would be the point in that? So, take your time; stretch the transformation across several panels. *Slow it down.* Let's really see it. We want the audience to say to themselves, "My god! Is that really the character that I like—that terrible creature?" That's a *good* reaction. The one we want.

Animals, such as cats, don't have to be drawn *realistically.* We're not talking tabby cats here. You can make up your own. They can start off cute and cuddly or vicious, like bobcats. The wilder and more dangerous they are, the more effective they are for female transformations. This is because occult bad-girl character types are driven by wild animal instincts. The good-girl types are moral and civilized.

From Vampire to Bat

Some transformation are prompted by an event, such as a full moon. Others are the result of the whim of the creature itself, as is the case with the vampire, who turns into a bat in order to fly away after gorging on human blood. Some characters will turn into creatures in order to kill.

MALE VAMPIRE METAMORPHOSIS

The Baron is charming, gracious, and handsome. Unfortunately for the women who fall for his charms, he is also a poisonous bat whose bite causes his victim to spiral into the bottomless blackness of the undead. Let's see him as he really is, unvarnished, in his true form.

The fingers grow long spines on which the wings will form. The feet elongate and will eventually mimic the batlike feet of rats. The hair and eyes become wild. The vampire is inwardly focused at this moment, all of his energy reined in and focused on the metamorphosis. If the victim is to escape, it must be now. Her time is limited.

The bat emerges as the clothes shred and are blown into the wind. More bat than human, the vampire is still double the size he will be when the change is complete. As he begins to emerge from the transformation, his entire demeanor becomes feral, aggressive—there's nothing "human" left in his heart from before. He would kill his former love if he had the chance. He is totally consumed by his new form. This is the tragedy of the horror genre.

In the final form, the vampire bat can fly, flee, or stay and attack. The chains he wears are a symbol of the eternal damnation to which he is tethered and from which he can never escape, except through death.

FEMALE VAMPIRE METAMORPHOSIS

A seductive look brings the stupid males of the species closer, like a black widow spider offering an invitation to a suitor.

Unlike the male vampire, when a female vampire begins her transformation, she looks enraptured, keeping her feminine mystique to set up the surprising next step and to avoid frightening off her victim.

Still beautiful, but weird things are starting to happen.

Suddenly, the beauty fades and the hideous vampire reveals herself with stunning abruptness—an effective technique. Note her arm position: She's no longer a coy, flirtatious female, but rather a domineering villainess bent on destruction.

In the final stage, darken the wings toward the bottom where the spikes are. This is an effective technique that gives all wings a more gothic look.

From Human to Winged Wolf

Remember, this is manga, not American, horror. So, the characters are not going to turn into Lon Chaney with wolf makeup. Manga is keen on taking traditional characters, such as wolves, and putting a fresh spin on them to create new, imaginative beasts. These two creatures are good examples of this—regular werewolves they're not.

MALE WOLF METAMORPHOSIS

This haunted young prince will transmogrify into a wolf-demon with devil wings. (Demons are very popular in manga and anime.)

Note the princely (read Prince of Darkness) robe.

Sometimes, especially with characters who turn into wolves, the transformations surprise even the transformed.

Clothes shred and fly off the character as animal joints appear. But, the character still retains quasi-human posture.

The final form offers a fresh interpretation of a werewolf, not an ordinary, run-of-the-mill werewolf.

FEMALE WOLF METAMORPHOSIS

Cat girls are a popular manga character type. They're friendly characters. So, we play a trick on readers to reel them in and then surprise them: We start the transformation by turning the occult woman into a cute cat-girl. Then we lower the boom. POW! She transforms further into a hideous creature, a real shocker—she's not the cutie we thought she was at all! In the end, she assumes her true identity for all to see: a vicious, winged, wolf-beast.

She starts as a typical occult goth beauty . . .

. . . and turns into a nonthreatening cat girl. This lures readers into thinking she's going to remain pretty and friendly.

Then comes the surprise change (not so pretty anymore) . . .

. . . before the final beast emerges.

From Man to Winged Panther: The Coil-and-Spring Technique

Another cool way of showing a transformation is to begin by having the character bunch up as the change starts. Then, once the character transforms, he suddenly pops open, presenting himself and his startling new look to the audience.

Have the figure start to close up as the process begins.

Note that inward-looking, turbulent characters are what make manga occult relatable to teen readers.

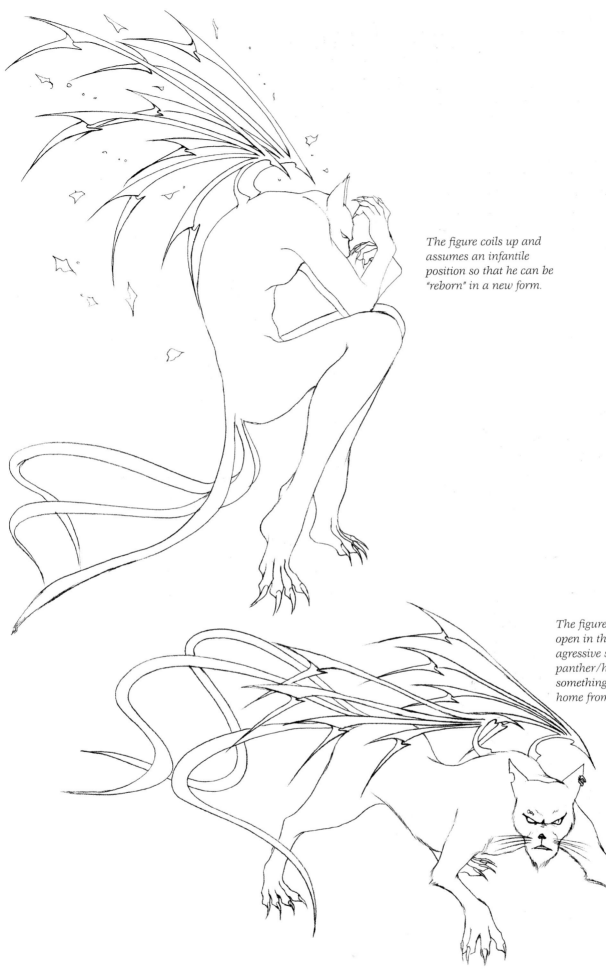

The figure coils up and assumes an infantile position so that he can be "reborn" in a new form.

The figure then springs open in this new form and agressive stance: the half-panther/half-dragon—not something you want to bring home from the pet shop.

From Woman to Unicorn Panther: The "Good" Transformation

At some point in every good story, the author or artists makes use of the element called the *twist*. We're familiar with the way conventional story lines go. If we read a familiar story, even if it's illustrated with well-drawn characters and interesting settings, the experience is likely to leave the reader underwhelmed. To make your characters memorable, you sometimes need to add an unexpected *twist* to make them less predictable and to make them stand out in the reader's mind.

One of the first hints that a transformation is taking place is the change in posture from human to animal. Don't leave out this crucial step.

For a "good" character, the face is sweet and innocent, and the clothes are gothic but are done with a lighter touch and more frills and bows.

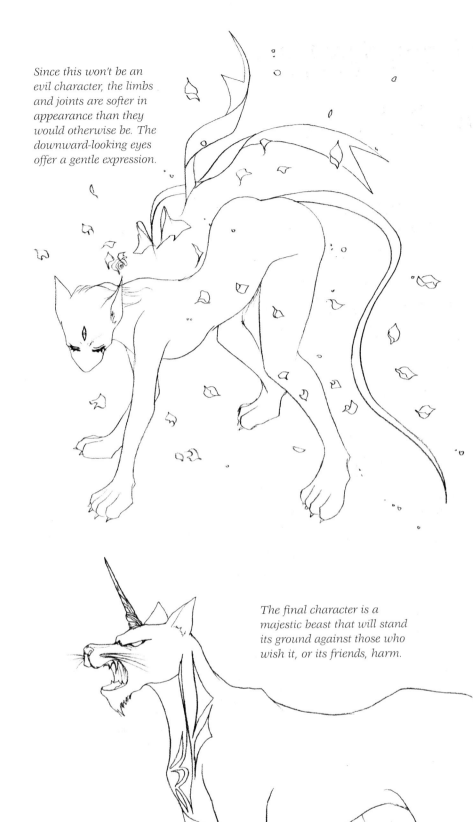

Since this won't be an evil character, the limbs and joints are softer in appearance than they would otherwise be. The downward-looking eyes offer a gentle expression.

The final character is a majestic beast that will stand its ground against those who wish it, or its friends, harm.

How do you do that? By making them uglier, grosser, more violent? Maybe, but hasn't that been done before? And isn't that a bit obvious? Perhaps you can be more clever in going about it. Maybe you can add a character who's a bit *different* from what you'd expect—not just more of the same.

For example, this girl is an occult character, but she's not evil. And the panther into which she transforms—although certainly powerful and intimidating—can be on the side of good. It has a unicorn-style horn on its forehead, which we generally associate with positive traits. Its posture is defiant, not vicious. The reader was expecting a transformation into a vicious, evil occult character. But here she is, transforming into a creature that's still on the side of good, taking a stand against the darker forces in her own world. Suddenly, you've got the makings of an interesting story. And that's good storytelling. But use such iconoclastic characters sparingly, because you don't want to undo the genre itself.

From Man to Dragon: The Visual Metaphor

Artists often plant devices to tip off the audience about what's coming. It's not so much to tease the reader, making this a parlor game, as it is to put the audience in the right mood. To do this, artists use visual metaphors or symbols. For example, what does a dragon have to do with this dark fellow? Well, ask yourself, What's the most prominent feature associated with dragons? Fire-breathing. And here is a man holding a candelabra teeming with flames. See the connection? It all comes together once he transforms. We begin to think of his candelabra as part of the dragon motif that remains when he's in human form. He likes to be around fire.

Another cool visual metaphor would be to invent a woman who turns into a snake. When she's in human form, she wears a long dress that winds around people in a serpentine way as she seduces them.

A Note about Reverse Transformations & Clothing

You can also reverse the transformation process, going from animal to human form. But note the following about the clothing: In a reverse transformation, the clothes have to suddenly appear on a character. Remember, an animal is covered in fur or scales and so on—and, therefore, needs no clothing. So, you've got to make sure the clothes begin to appear on the animal *before* its anatomy looks too human. That way the imagery remains appropriate for all audiences. The clothing can appear as a swirling special effect during the transformation, or it can appear suddenly on the character, going from creature to person in one leap.

From Woman to Dragon: Transformation by Magic

Strange, magical forces sometimes provoke transformations: a bite on the neck, a potion from a chalice, or the sweet pollen from an exotic black rose. They can be slipped unknowingly to the victim so that the victim's soul is taken from her before her very eyes—a most frightening event—as she watches her own unholy mutation from good to evil. Conversely, the transmigration of the soul can be volitional, perhaps even part of a ritual between lovers destined to rule together in darkness forever.

A silver chalice is a well-established prop for delivering a secret potion that will trigger a dark transformation.

SPARKLES AND MATTER FLOATING IN THE AIR CREATE A FANTASY FEELING

DRAGON CLAWS BEGIN TO EMERGE

Once the potion is taken, there is no return to the land of the living. Note: Swirling objects are very important in transformations; use what's available in the drawing (hair, clothes), or if nothing lends itself to this motion, draw energy lines swirling around the figure.

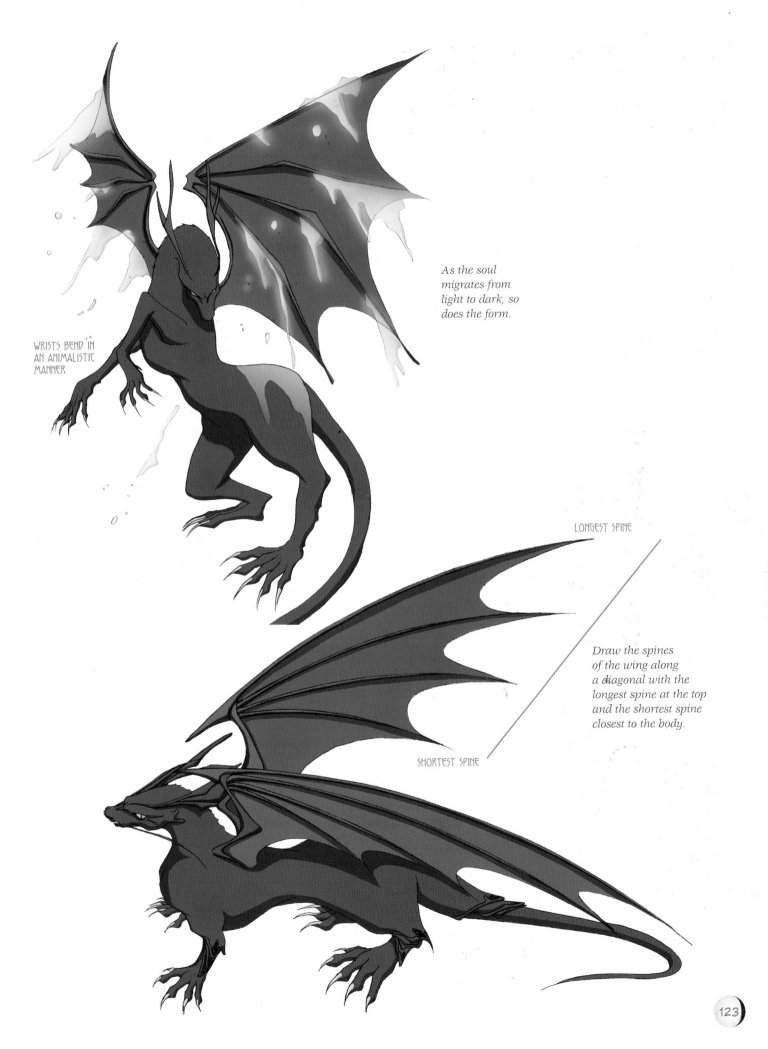

WRISTS BEND IN AN ANIMALISTIC MANNER

As the soul migrates from light to dark, so does the form.

LONGEST SPINE

SHORTEST SPINE

Draw the spines of the wing along a diagonal with the longest spine at the top and the shortest spine closest to the body.

CREATING THE OCCULT WORLD

The world of the occult is part of the fun.
It's like a nightmarish amusement park.
Nothing is as it seems. Floors can move.
Mirrors can talk. We'll see how to create
some of the most popular types of occult
environments and how to illuminate them
with moody light and shadows in order
to generate the most suspense.

Establishing Mood with Shadows

LIGHT SOURCE

LIGHT

SHADOW IN HAIR
WHERE OVERHEAD
LIGHT DOESN'T REACH

LIGHT

SHADOW SIDE

ARM CASTS
SHADOW
ON HIPS

LIGHT SIDE

LIGHT

SHADOW WHERE JACKET
OVERLAPS PANTS,
CASTING A SHADOW

SHADOW ON BACK
OF FIGURE WHERE
LIGHT DOESN'T HIT

JACKET CASTS
SHADOW ON PANTS

LIGHT

JACKET ALSO CASTS
SHADOW ON GROUND

OVERHEAD LIGHT SOURCE: NORMAL LIGHTING/NEUTRAL MOOD

Indoor overhead lighting is the most common type. It falls on the hair, shoulders, arms, hips, and sides of the clothes—but not on everything. What it doesn't fall on remains in shadow.

If you're going to draw characters who dwell in the land of darkness, you've got to add, well, *darkness*! Shadows are sinister because they can eerily wrap themselves around a character, almost as if they are sentient beings themselves. They can assume the shape of an object or cast that shape onto another surface. Shadows can stretch or disappear completely. They are mysterious, hiding the things we fear from plain sight. They also create a tense, thick atmosphere, which heightens the suspense of any scene.

It's sort of counterintuitive, but to draw shadows, you have to think about where you want to place the *light*. Shadows are what result when light hits an area. If there's no light, there's no shadow. So, start to think of the direction of the light hitting your character or your scene. The light may come from one direction or angle, two directions, and sometimes even three directions. But, it's not everywhere, all the time—not even on a hot summer day outside. Light always comes from a direction. And, where it doesn't hit is where the shadows appear.

You've got to start thinking about it in this logical way. If you don't—if you shade areas randomly, based simply on what looks good to you—you'll end up with shadows in places where light hits and light in places where shadows should be, and the image will end up "checker-boarded" with pockets of light and shadow. It looks better when it looks right. Here's how it should work.

Hint: Generalize

Don't be too detailed or literal with shadows. Simplify them, and make them more of a general design than a strict copy of the outline of the figure. A shadow that's too intricate will look weird. Shadows just don't work that way.

LIGHTING FROM BELOW: MENACING MOOD

When you light a character from below, you get a decidedly different mood. It's spooky, no? This is one of the times that a light source doesn't have to represent anything occurring in reality. In other words, you don't have to show the character standing over a fireplace or make sure that another character is holding a lamp below him to justify the low-light effect. We light him from below for purely emotional reasons—because it heightens the drama.

BACKLIGHT: SUPERDRAMATIC MOOD

When you light a character from behind, a rim of light (edge light) falls on the outline of the figure. It's a very cool look. The contrast of having a large, dark figure outlined in bright light makes the character both mysterious and impossible to ignore.

The parts of the figure that protrude—the chest, collar, and face—are hit with the light. The parts that recede—the neck, shoulders, back of the hair, and forehead—are all bathed in shadow (because the light doesn't hit them).

LIGHT SOURCE

LIGHT SOURCE

Even though the eyes of a backlit character should, technically, be in shadow like the rest of the figure, you still add eye shines to them. The shine is what gives the eye life.

Rendering Shadows

There are many ways to render shadows. Use what feels best to you. Much of the manga you see in graphic novels is shaded by the artist with simple cross-hatching of the pen. Some artists use pools of solid blackness done with a pen or marker. Artists can also use gray markers for shading. I've seen some use a combination of black ink for the outlines of the characters and a smooth, consistent pencil line for the shading. (Don't press too hard on the pencil if you use this method.)

There are also computer programs available that allow you to scan your images and use only the most basic elements for shading.

Using Shadows: You Don't Need a Reason

LIGHT SOURCE

Although the shadows should fall in a logical way, you don't always need a reason for introducing them into a scene. It's reason enough that shadows enhance mood; they make the characters bold, the moment emphatic. And, they also do another thing: They make the figure appear three-dimensional instead of being left empty—and flat—with only black lines on white paper. The characters tend to take on a feeling of roundness, solidity, weight, and emotional depth.

However, there are some trade-offs, and you have to weigh the pros and cons. Black and white can be stark, intense, and powerful. Some characters, scenes, and even entire graphic novels are better suited to the explosive high-contrast style of black and white—with no shadows or gray. Even then, you can use pools of black as your shadows, thereby applying what you've learned here. So experiment. And allow the subject matter to dictate your choice of using grays or blacks for shadows.

LIGHT SOURCE

LIGHT SOURCE

127

Shadows on the Ground

Shadows that fall on the ground under characters fix the figures in place so that they don't appear to be floating on the page. Ground shadows also show the audience where the horizon is. In addition, they are another tool in the artist's arsenal. For example, a jagged shadow underscores the violence of an action pose. A small shadow adds a poetic feeling to a lonely moment.

LIGHT SOURCE

With the light source located at about two o'clock, the shadow is long. If the light source were even lower—for example, down at the character's right fist—the shadow would grow longer still.

Use a forward-leaning shadow for an action figure.

LIGHT SOURCE

GENERALIZED SHADOW SHAPE

SHADOW PROVIDES SOLID INDICATION OF GROUND

LIGHT SOURCE

LIGHT SOURCE

High Light Sources vs. Low Light Sources

Here's a rule that will make drawing shadows much easier: The higher the light source, the shorter the shadow. Conversely, the lower the light source, the longer the shadow. So, when the light source is very high—say, directly overhead—the shadow on the ground is very short, but when the light source moves lower, the shadow grows longer.

With the light source almost at noon, high overhead, the shadow is at its smallest.

LONE WARRIOR

For her, a small shadow underfoot signifies her world: She is an island unto herself.

Special Effects Shading

Shading can also be used to heighten the look of special effects, making the moment more brilliant. But remember to make the special effect burst of light really stand out—the rest of the character must be in shadow.

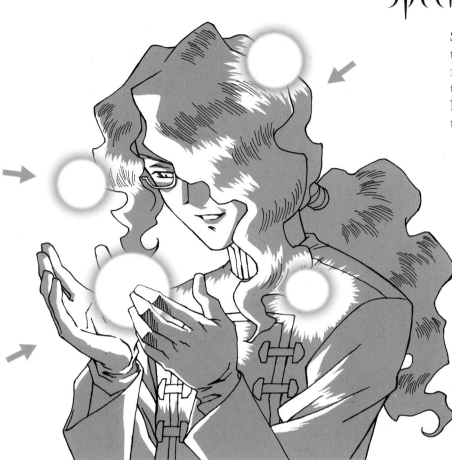

MAGICAL GLOW EFFECTS

Magical effects have soft shading that makes them enchanting. In order for the spheres of light to look so luminous, the character (as well as the background, if there is any) needs to be dark. The magic sphere gives off light, as if radiating warmth.

GUNFIRE BURST

The burst from gunfire is a sudden and intense flash. The flash itself is the light source. The blast of light cuts out a small, sharp template of light in the character, the edges of which are hard and severe. Everything else falls off immediately into shadow.

Mirrors and Reflections

Mirrors and reflections hold a strange fascination. They are a common visual theme in manga occult stories about possession and other spooky stuff. There's something weird and haunting about the world that lies on the other side of the mirror. Is it real or just a reflection? Can we step through to some other place where we will come face to face with a duplicate of ourselves? So, how do you incorporate mirrors and reflections? Take a look.

REFLECTION IN GLASSES

Instead of drawing a picture of bats flying on the horizon, for example, try drawing the bats as a reflection in a character's eyeglasses. Since the lenses are always slightly curved, this will warp the horizon, distorting the picture plane in a bizarre way and resulting in a creepy look. Tree branches will bend together as they reach skyward, almost like fingertips. But here's the point to remember: You can use reflections and mirrors as a substitute for ordinary shots to create extraordinary images.

REFLECTION IN WATER

The reflection starts to speak back to its source. Then you don't know who the master is—the person or the reflection!

CAUGHT IN A MIRROR

Suddenly, the world starts spinning, and your character finds herself caught in a mirror-nightmare world, with no way back!

In this particular type of shot the reader sees what the eye is seeing, as reflected in the pupil. It's a very dramatic angle and an extreme close-up.

STEPPING THROUGH THE MIRROR TO THE OTHER SIDE

The figure must move slowly, gracefully, as if moving through water, with hair and gown flowing.

IN HANDHELD MIRRORS

The silver handheld mirror is a precious, old-fashioned. ornament, almost witchlike in nature.

Dreams and Nightmares

The world of occult and horror is an exciting and fascinating genre because nothing is quite what it seems. Beasts are men. Women are vampires. Children are possessed. You've got to stay on your toes. It keeps the reader on edge, and that's a great place to be—out of the comfort zone and glued to the next panel, the next sentence, the next illustration.

In occult and horror, regular scenes sometimes turn into dream sequences or even nightmares. These are very cool, visually entertaining panels that are like entering a haunted-house amusement park ride. For example, maybe you want the character to discover that the evil one has placed her in a nightmare from which she can't wake up. That's a visually dizzying effect.

CHILD'S BEDROOM: ORDINARY

Peaceful, serene, neat. Plenty of vertical and horizontal lines translate into a feeling of stability.

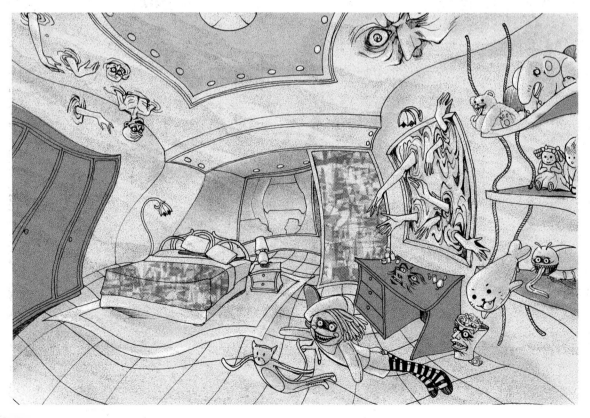

CHILD'S BEDROOM: DREAM SEQUENCE

The straight lines are gone; everything goes wiggly. Inanimate objects take on life and personality. The mirror becomes a portal through which "others" try to enter. Walls, too, become doorways to other worlds, as witnessed by the hands reaching through the walls and ceiling in the upper left corner. Objects and things (lamps, pillows, and so on) rock back and forth. Faces appear in objects (the work desk, trash can, and ceiling).

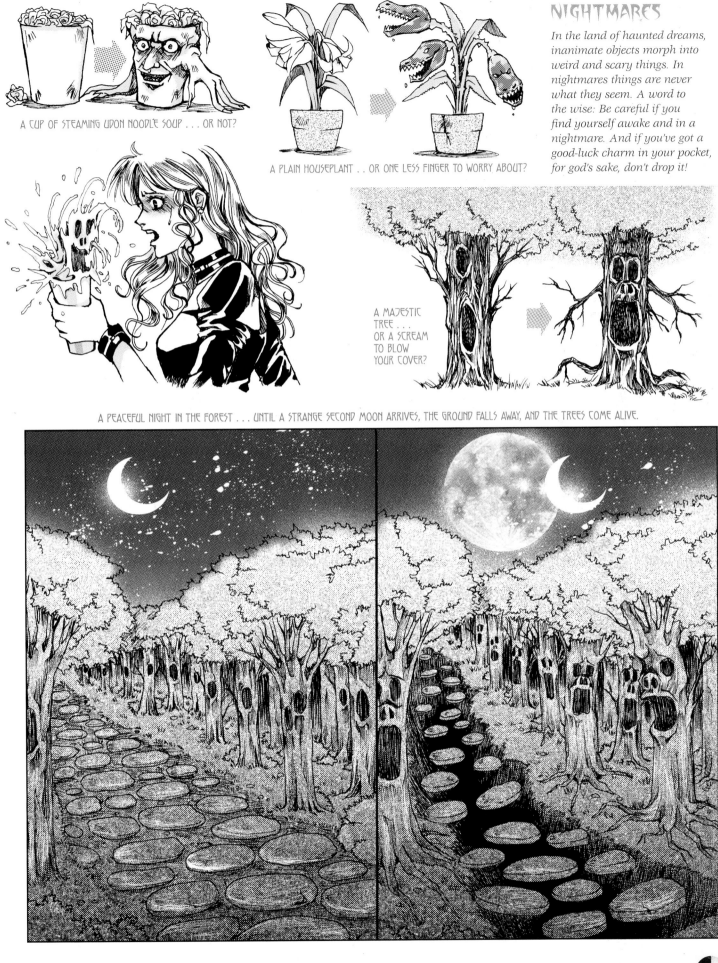

A CUP OF STEAMING UDON NOODLE SOUP . . . OR NOT?

A PLAIN HOUSEPLANT . . OR ONE LESS FINGER TO WORRY ABOUT?

NIGHTMARES

In the land of haunted dreams, inanimate objects morph into weird and scary things. In nightmares things are never what they seem. A word to the wise: Be careful if you find yourself awake and in a nightmare. And if you've got a good-luck charm in your pocket, for god's sake, don't drop it!

A MAJESTIC TREE . . . OR A SCREAM TO BLOW YOUR COVER?

A PEACEFUL NIGHT IN THE FOREST . . . UNTIL A STRANGE SECOND MOON ARRIVES, THE GROUND FALLS AWAY, AND THE TREES COME ALIVE.

133

Symbols of the Occult

Symbols of the occult are a very important part of this genre. They decorate and embellish scenes and images and even the clothes. Occult symbols even intimidate non-occult characters. A list of symbols appears below, but you don't have to use all of them simultaneously. You can use a combination of only a few. It all depends on the type of character you're trying to create and how much he or she is trying to blend in as an ordinary human.

Symbols

Pentagrams

Thorny horns

Facial tattoos

Chains

Devil or elfin ears

Crows, ravens, or owls

Bats

Moon

Torn drapery

Bones

Rings

Executed dolls

Spider webs

Skulls

Chalices

Black cats

Chains with large medallion

Bottles of potions

Top hats

Masks

Medieval blades

Stone furniture

Witch's cauldrons

Eerie Backgrounds

I want this book to grow with you, to take you from the basics of drawing faces and bodies to designing your own characters to, ultimately, placing characters in full scenes that you compose if you want to take it that far. So to that end, here are some suggestions of locations for occult-and-horror stories that remain extremely popular with readers from the U.S.A. to Japan and everywhere in between. These locations are designed more to inspire you than to give you a rigid template to copy. These are simply a few good choices to keep in mind when you want to set the mood for your scenes.

DESERTED FARMHOUSE

A broken-down car (no good for escape—it's just a tease). Overgrown weeds. A small house. You can hide, but you can't run . . . very far, that is. There's nowhere to run to! And when night falls, it gets very, very dark. The enemy knows the lay of the land, but you don't.

CASTLE BY THE SEA

A huge electrical storm. No boats. No horses. No way out. Just a cozy couple of nights at the inn with the Baron and his wife. Lucky you. Hope you packed a lot of Band-Aids. (And note the crushing whitecaps as they splash up against the rocks, making a dramatic display of the storm's power.)

EMPTY PLAYGROUND IN THE RAIN

Bleak. Lonely. Someone is watching. The rain slashes down at an angle. Leaves scatter in the wind. Swings are pushed up and sideways. Wind is a bad omen in the occult genre, a harbinger of things to come.

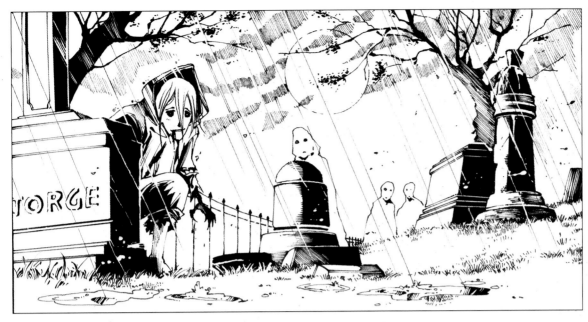

CEMETERY

Wrought-iron gates. A lawn with tombstones of varying shapes and sizes. Silhouettes of leafless trees with twisted, knotty branches. These are all the prime ingredients for a cemetery. In addition, there's always a full moon in a cemetery because a full moon casts a hard shadow, which results in a lot of rich blacks. Without a full moon, the light would be diffused and soft.

NIGHT IN THE CITY

Nice place for a little stroll. If you're a zombie, that is. Draw the scene at a diagonal to give the scene an unsettled feeling. This is called a tilted frame look. It's a good way of making your readers feel agitated as they go to the next scene. And that's how they want to feel when reading an occult-and-horror book: on the edge. But you've got to provide the payoff in the following panel with something good. You cannot—I repeat, cannot—continue to build up the suspense without providing a payoff.

NIGHT IN THE PARK, ALONE

You'd think you'd be safer out in the open than holed up in a shack in the woods. But, you'd be wrong because behind each tree, under each staircase, walking across every meadow and baseball diamond are dozens of zombies—closing in from around the park's perimeter.

Sequence

So how, exactly does he do it? How does he charm and mesmerize his beautiful victims, and deliver the final Bite of Darkness? You can't communicate this information to your reader if you don't put the scenes in the proper storytelling sequence. All of the essential "beats" must be laid out, creating a sequential scene that moves like clockwork. The following pages will take you through a pivotal scene panel by panel, breaking down the pacing and plot development for you.

SETTING THE SCENE

We come to the moment of truth, the moment we've all been waiting for: when all will be revealed. It is the annual ball at the Baron's castle. Only the Who's Who of high society are in attendance. They scene begins with them mingling. The host, the young Baron, is an introspective man, set apart from the others and unnaturally young for his years. He will honor his guests with his presence—while at the same time looking to reinvigorate his youth by unholy means. He's hungry, distracted, on the prowl for new prey.

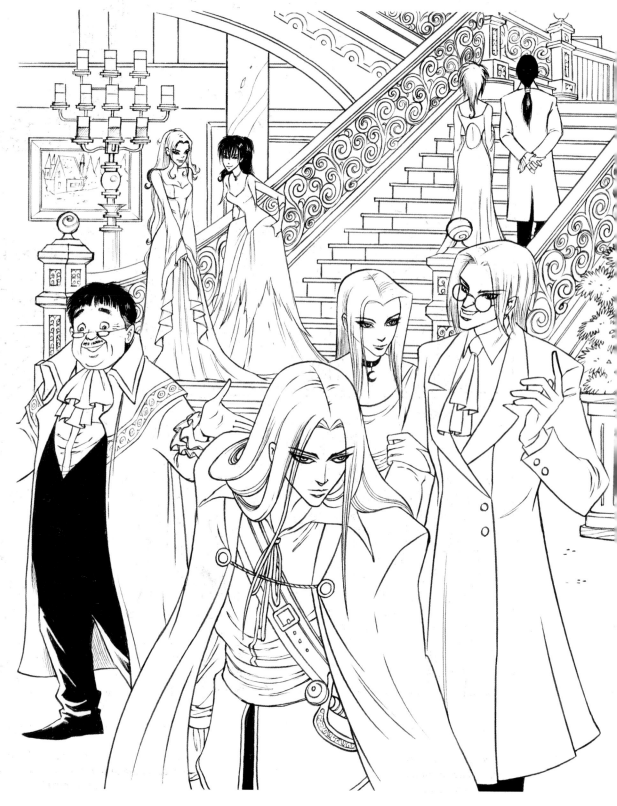

THE LOOK

The Baron catches the
eye of a beautiful heiress.
She is standing on
the balcony, alone.

THE FLIRTATION

They talk, flirt. She finds him
charming, but somehow, she feels
uncomfortable around him. He
invades her personal space.

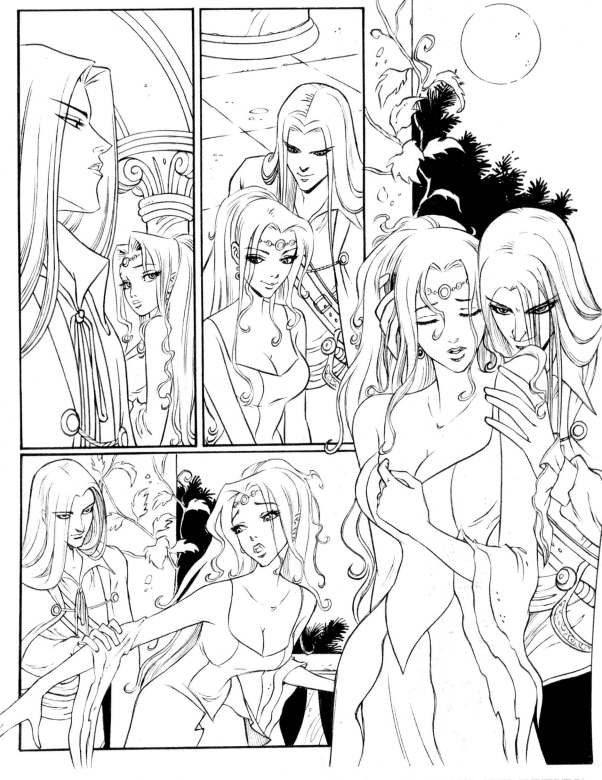

THE TEMPTATION

She doesn't trust herself around
him. She leaves him and goes
outside to the balcony.

THE PURSUIT AND SEDUCTION

He follows her. Brings her in tight. She finds
herself weakening and dares not look at him.
(I, too, have this effect on women.)

THE SPELL

He turns her around so that she looks deeply into his eyes. She's caught fast in his spell.

THE KISS

They kiss passionately. (Here's where they usually tell me they're tired and have a lot of work to catch up on but had a really great time.)

THE SUBMISSION

She leans her head back, offering him her neck.

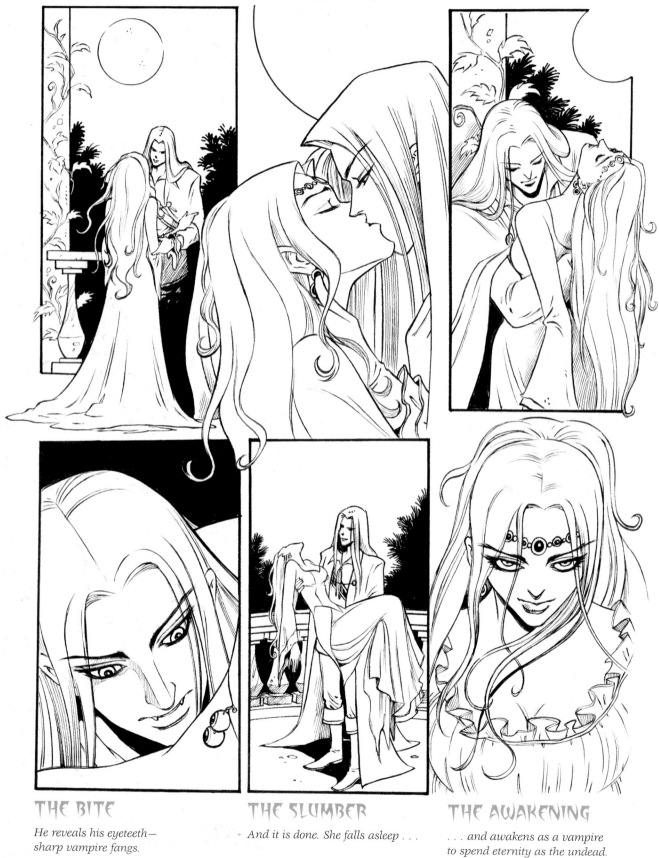

THE BITE

He reveals his eyeteeth— sharp vampire fangs.

THE SLUMBER

And it is done. She falls asleep . . .

THE AWAKENING

. . . and awakens as a vampire to spend eternity as the undead.

The Colors of Manga Occult and Horror

The occult-and-horror genre is more than a style or a drawing; it's also a mood. You cannot use the same palette that you would to color bright, happy shoujo-style manga. It would completely sabotage all that hard work you put in at the drawing board. *Dark* and *mysterious* are the adjectives that should inform your world of color choices here. And note that *dark* and *mysterious* are interesting and compelling color strategies. Just because they're not bright doesn't mean they're not stimulating to the eye. Just keep these four important points in mind:

🖤 Don't go so dark that the lines and characters are hard to make out.

🖤 Every dark image needs bright areas in it or it will appear to fade away.

🖤 Even a darker image should use a wide range of colors.

🖤 *Dark* doesn't man *dreary*.

ORIGINAL PENCIL SKETCH

BLACK-AND-WHITE VERSION

SHOUJO COLORS

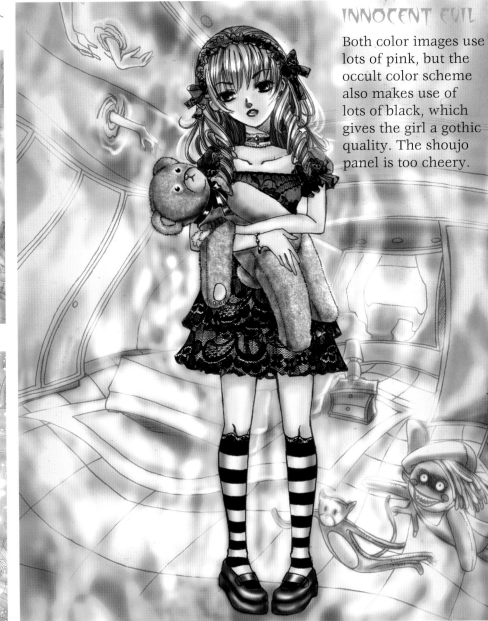
OCCULT COLORS

INNOCENT EVIL

Both color images use lots of pink, but the occult color scheme also makes use of lots of black, which gives the girl a gothic quality. The shoujo panel is too cheery.

VAMPIRE WOMAN

The wan skin color in the occult version shows us that she's a creature of darkness. The sky behind her indicates that it's night. Time to wake up! The shoujo colors are too warm and soft. This vampire looks much too healthy. Looks like she works out at the gym every day and drinks a glass of milk with each meal. Also, I can't tell what time it is from looking out the archway behind her, and that's a problem, but it's solved in the version with occult colors.

ORIGINAL PENCIL SKETCH

BLACK-AND-WHITE VERSION

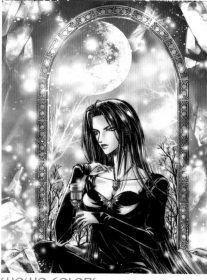

SHOUJO COLORS

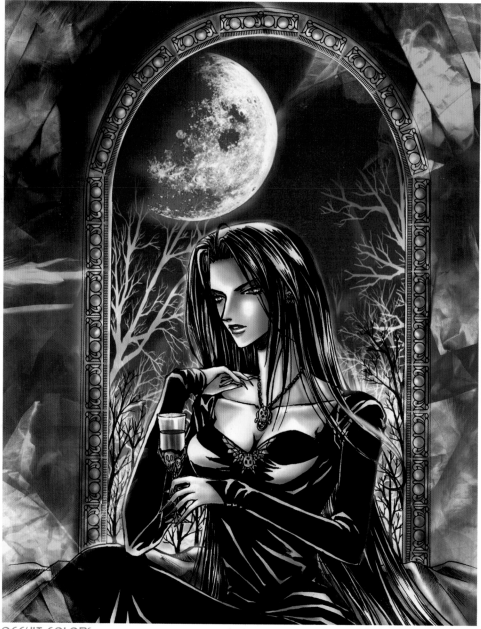

OCCULT COLORS

DASHING VAMPIRE ARISTOCRAT

Yes, the fantasy colors are too bright; however, with his cape and sword, he's almost straddling the fence between fantasy and occult, which are sometimes blended. So, this is pushing the envelope a bit, but not by that much.

In the occult version, darkness reigns with a warm, golden-reddish hue. Can't argue with that. Feel the heat?

Bring up the red (a popular occult color), add a good amount of green (a popular fantasy color), and you've got a pleasing mixture of two genres in the fantasy/occult combo.

ORIGINAL PENCIL SKETCH

FANTASY COLORS

OCCULT COLORS

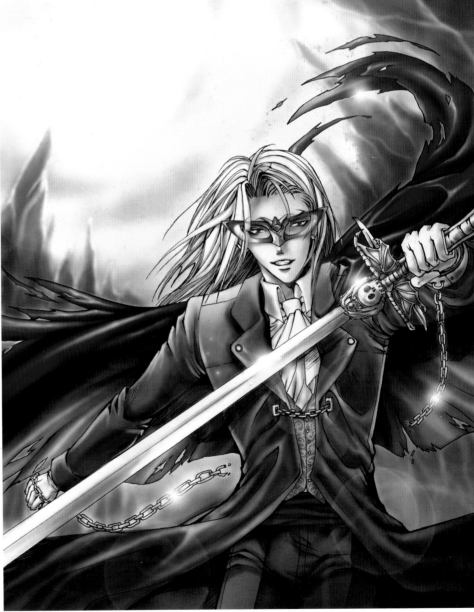

FANTASY/OCCULT COMBO

Index